HOW TO DRAW
PEOPLE

*Step-by-Step Lessons for
Figures and Poses*

JEFF MELLEM

NORTH LIGHT BOOKS

CONTENTS

Overview ... 4

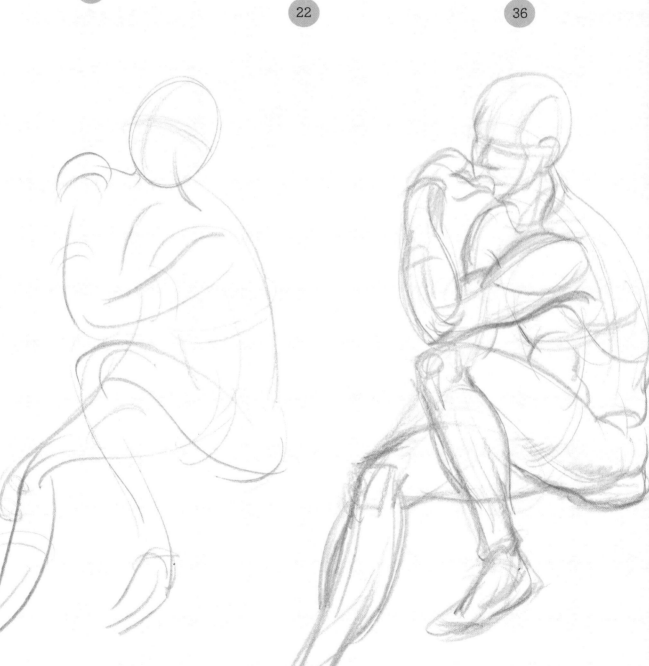

CONTENTS

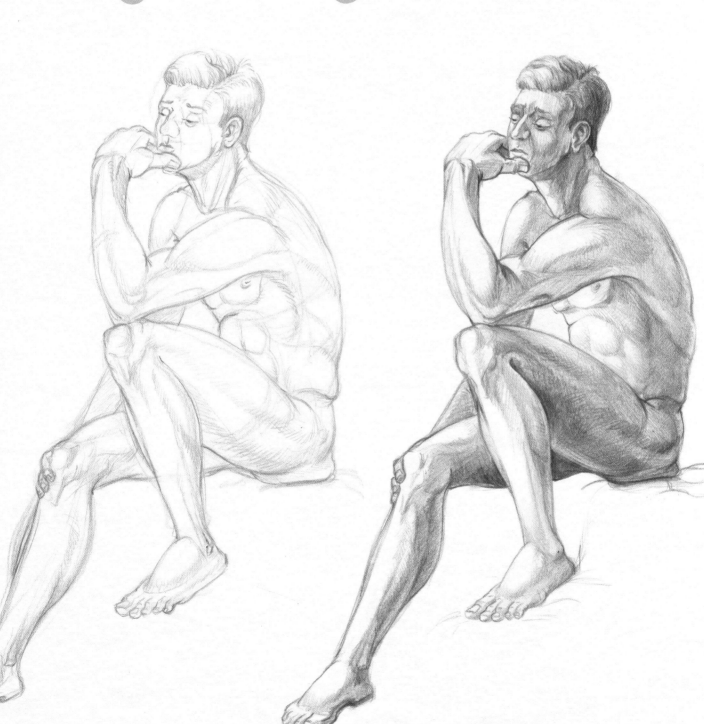

OVERVIEW

Knowing how to draw the figure is a great skill for any artist to have. If you are interested in working in one of the narrative arts, such as films, comics, video games or illustration, being able to draw and invent figures is essential. Even if you're more interested in expressing abstract ideas through fine art, having the skill to draw a figure in any pose opens up a whole world of expressiveness.

Learning to draw people can seem like a daunting task. The human body has so many muscles and features that trying to understand all the parts quickly becomes overwhelming. Most often artists who want to learn the human form begin by grabbing an anatomy book and trying to figure out what all the bumps are on the model. The really dedicated students may even memorize the names of the muscles. Unfortunately, having a medical understanding of the human body does little to help you draw it. The good news is that anyone can learn to draw the figure, and it's a lot more fun than memorizing an anatomy book. If you start with the basics, you can begin to draw a simple figure today. As you learn more, you will be able to add more detail and complexity to your drawings, and you will even be able to invent figures and poses from your imagination.

In the beginning, it's better not to pay attention to specific muscles. Instead, I teach some fundamentals that are designed to build your spatial reasoning abilities and will lay the foundation for drawing from imagination. Each new chapter builds on the previous one to give you the skills needed to add complexity to your drawing. By the end of each chapter, you will be able to draw the figure with greater detail.

It's important to have an overview of the process so you can see where you are going and how the concepts interconnect. The book is divided into five chapters (called levels) that will take you from a simple armature to detailed breakdowns of the different body parts. If you take your time to master the skills presented in each chapter, you will have an easier time in subsequent chapters.

Level 1

Getting a sense of proportion and range of motion is vital to inventing figures and poses, and the armature is the perfect tool for that task. An armature looks like a stick figure with shoulders and hips. It's very simple to draw and an easy way to start learning both proportion and how to design poses. Essentially, the armature is a very simplified skeleton.

Level 1 focuses on using the armature to draw a figure in proportion and provides a basic understanding of human mechanics. In Level 1, I also introduce the first steps of drawing three-dimensionally using the sphere. Gesture drawing is discussed as a more fluid first step to figure drawing with balance and rhythm.

Level 2

Using the sphere and cube to add volume to the armature, you will learn to create a simplified, dimensional skeleton. While the simplified skeleton dispenses with many individual bones, it is dimensionally and proportionately faithful and acts as a foundation for the muscles.

Level 3

With the underpinnings of the figure in place, the next step is to build out the figure using basic volumes, fleshing out the simplified skeleton by joining and combining boxes, spheres and cylinders. This simplified figure will begin to look more human despite lacking any muscular anatomy.

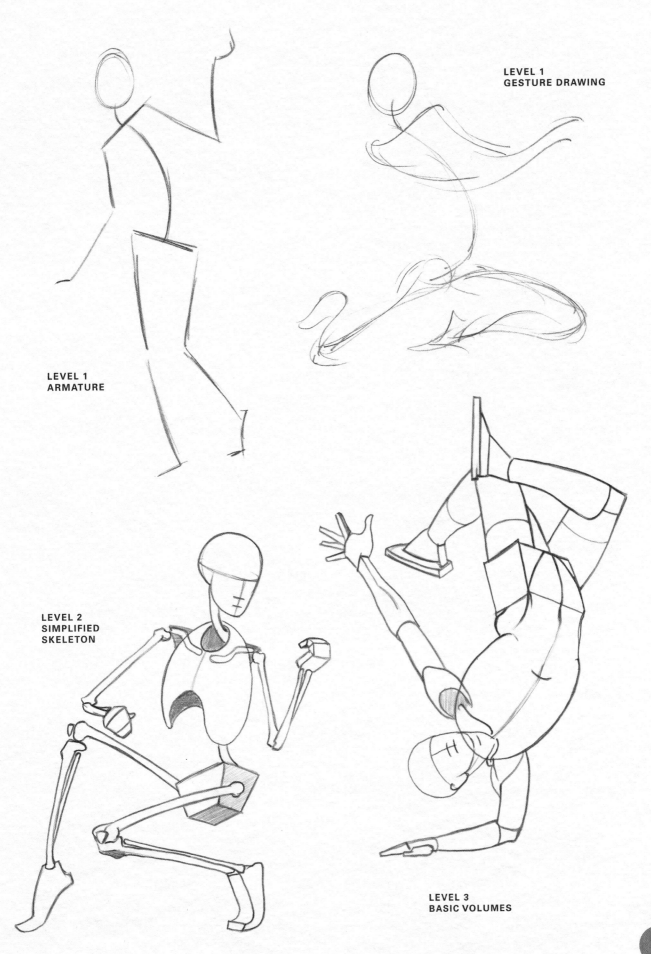

LEVEL 1
GESTURE DRAWING

LEVEL 1
ARMATURE

LEVEL 2
SIMPLIFIED
SKELETON

LEVEL 3
BASIC VOLUMES

5

Level 4

Once the basic three-dimensionality of the figure is established, the forms can be molded to more accurately reflect the body's shapes and rhythms. The shapes of the body are mostly influenced by the largest muscles. Learning the three-dimensional shapes of these large muscles is the first step to creating figures that are anatomically correct. Learning the forms of the muscles is vastly different than learning anatomy from a medical book. You have to learn how to draw them when the muscle is stretched, flexed or relaxed. You will have to be able to see the muscles in your mind in three dimensions and be able to draw their shapes from any angle. These skills aren't complicated once you understand that you are drawing three-dimensional forms that are easily molded to fit your subject.

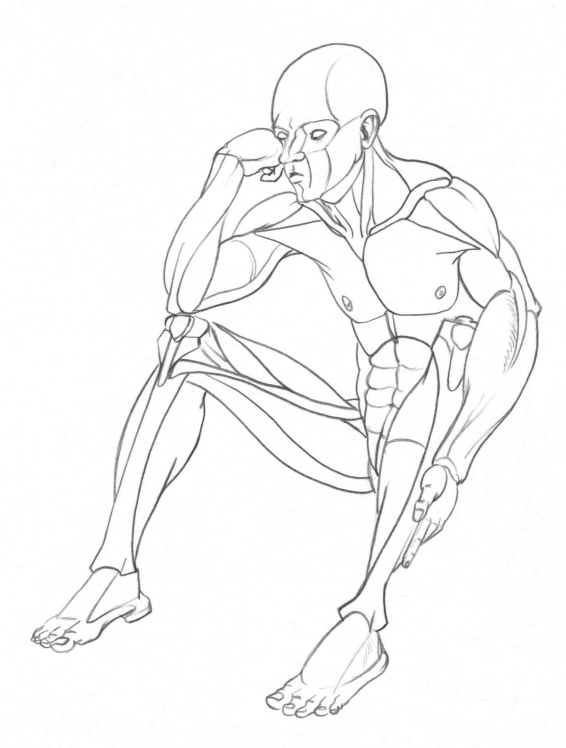

Level 5

This final chapter shows you how all the lessons tie together and give you a step-by-step process for drawing a figure. You will be able to use your skills of three-dimensional drawing and anatomy to create a convincing figure. It's important that you don't end up with a final image that looks like an anatomical model or a cartoon made of boxes and cylinders. Knowing what to put on the page and what to leave off is an important part of developing your drawing. Finally, discovering how you can create your own shape and forms to depict your figure will give your drawing a unique style.

ARMATURE

The best way to learn to draw the human figure is to start as simple as possible. Forget about tracing contours. Forget about shadows and values. Forget about skin and bones and facial features. What you need to do is boil the figure down to its essence, something so simple that it can be drawn quickly, something so clear that there's no question about what it represents.

When people who don't know how to draw want to sketch a person, they often end up with a stick figure. That's about as simple as you can get. The problem with the standard stick figure is that it doesn't possess the information on which to base a drawing. However, with a couple of additions and modifications, you can turn a simple stick figure into a foundation for a drawing.

If you take a stick figure and add some shoulders and hips, you get something that looks a lot more like a human than the usual stick figure. If you also add in some hands and feet and some bends at the elbows and knees, some volume to the head and keep all the parts roughly in proportion to a real person, you'll end up with something that's both easy to draw and recognizable as a human. In art, this simplified figure is called an *armature*.

Learning to draw an armature is a great place to start in figure drawing because you don't have to worry about making it look like the person you're drawing. Once you take away all the details, what you're left with is a diagram of how someone is posed. By reducing the figure to this simple representation, you gain the power to analyze and exaggerate poses you see and invent poses you imagine.

One important note about drawing the armature: This is not gesture drawing. Gesture drawings are a better way to build a drawing because they show both the pose and the proportion of your figure (like an armature does) but also give your drawing a rhythm and flow. The armature is a more concrete, rigid system that hones your sense of proportion and is an easy and clear way to build a pose. Gesture drawing is discussed later in this chapter. For now, stick with the armature as a way to help you see beyond the surface of your subject.

ARMATURE

1 Draw the Head

The first step in drawing an armature is to draw an oval for the head. I start with the head because it establishes the proportion for the rest of the body. Pay particular attention to the angle at which the head tips to the left or right.

When you draw your oval, you don't need to go around and around. Just draw an ellipse in single lines once around or so. It helps to practice drawing circles of various sizes and elongations until you can draw a simple oval shape consistently.

2 Draw the Face Map

Now, you must define how the head is tipping forward or backward. You have to think of your shape as a sphere and not a flat circle. A sphere has three dimensions, where as a circle has only two. I know the page is flat and your circle only has two dimensions, but you can make it appear to have depth simply by wrapping a line around the sphere's equator.

To see how this works in real life, wrap a rubber band around a ball or draw a line around the middle of a balloon. As you tip the ball or balloon away from you, the curve of the line appears to arch upward; if you tip it forward, the arch will appear to dip downward.

This line around the middle of the oval represents the eye line. The chin will fall at the bottom of the oval. The bottom of the nose is halfway in between the eye and the chin. The mouth is halfway between the nose line and the chin. You can add those lines if you want to show the direction and tilt of the head.

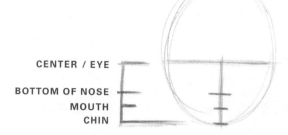

CENTER / EYE
BOTTOM OF NOSE
MOUTH
CHIN

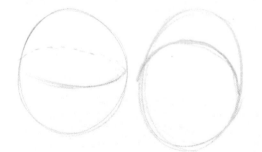

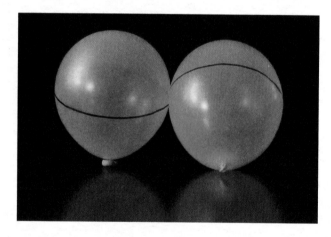

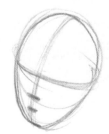

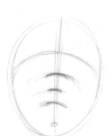

3 Add the Neck

You will want to add a line for the neck. This line generally represents the spine. Don't worry about anatomy yet; just have the line start at the back of the sphere opposite the face.

The neck bends and twists to a large degree, so be sure to give it some curvature. Even when a person is looking straight forward, you can see the natural curvature of the neck in profile.

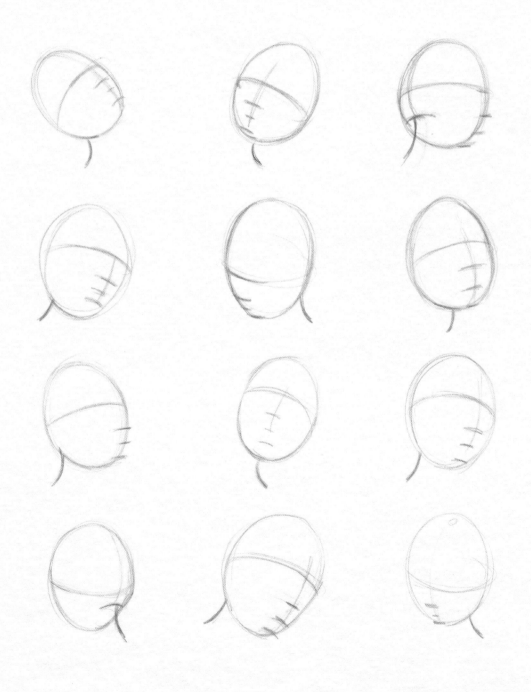

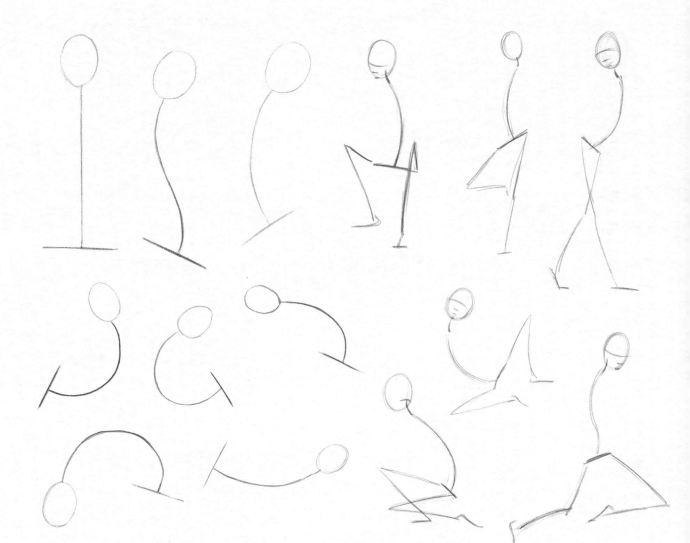

4 Draw the Torso

The next step is to work down the body to the feet. Draw a line that represents the torso. Like the neck, this line follows the general motion of the spine, but you're not trying to draw the curves of the spine itself. Don't worry about the outer curve of the spine at the rib cage or the inner curve at the waist. You're trying to capture the general movement of the torso down to the hips.

5 Add the Hips

On the armature, the hips are represented by a straight line that is at a 90-degree angle from the base of the spine. This makes it easy to figure out how to draw the hip line. Once you've drawn the torso line, the hip line will be perpendicular to it.

Facing forward, the hips are wider than the head, but as the body turns to the side, this line foreshortens and could be as small as a single point.

6 Draw the Legs

The legs should be about as long as the head, neck and torso combined (assuming the body isn't foreshortened), bending at the middle for the knee.

Add a simple line to indicate the direction of the feet and to anchor your figure on the ground.

7 Draw the Shoulders and Arms

Each shoulder moves independently, so they aren't represented by a straight line like the hips are. When the shoulders are shrugged or rotated forward, the shoulder line should reflect this with a curved line. The shoulder line connects to the torso at a right angle, similar to the hips, but it curves up, down, forward or back as it moves away from the body, according to the pose.

Add the arms and hand in a similar fashion to the legs and feet, only a little shorter.

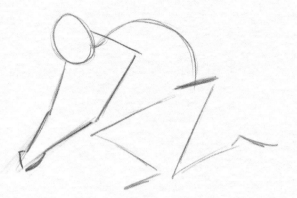

PROPORTIONS

Once you're comfortable posing an armature, you'll need to start paying attention to getting the proportion correct. Every person is a little bit different. Some people have long legs and a short torso. Other people might have long arms or wide shoulders or a squat head, so you have a lot of leeway in drawing these things.

That said, the classical proportion of an adult is roughly seven and a half heads tall. The top of the head to the pubic area is four heads high. The legs are about three-and-a-half head lengths tall, but many people stretch them to a more statuesque four heads.

These proportions only matter when the figure is standing straight. As soon as a limb or the torso moves forward or backward, the foreshortened perspective makes the proportion seem shorter. If you're drawing from life, the easiest way to measure distances is to visually measure the height of the head using your pencil at arm's length. Then use that measurement to plot out the rest of the body. Eventually you'll develop a sense of how much the proportions change when foreshortened, which will help you when you're inventing a figure from imagination.

This armature is seven and a half heads tall. The horizontal lines show where different parts of the body fall when you use the height of the head to measure the proportions. For example, you can see that from the top of the head to the bottom of the torso is four heads tall. When a limb moves away from the body or is foreshortened, you can use the head as a reference to figure out where to start and end your lines.

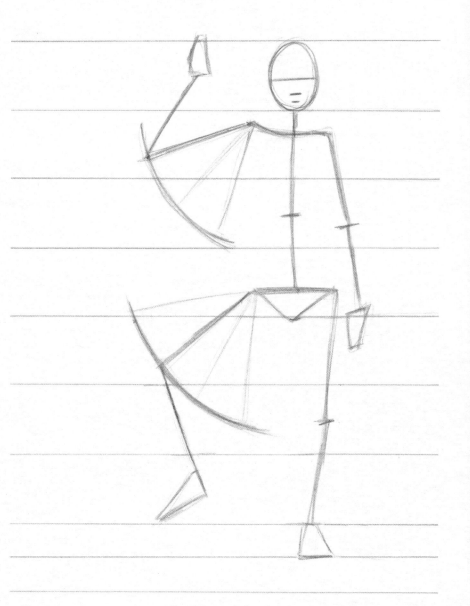

USE PHOTOS TO DRAW AN ARMATURE

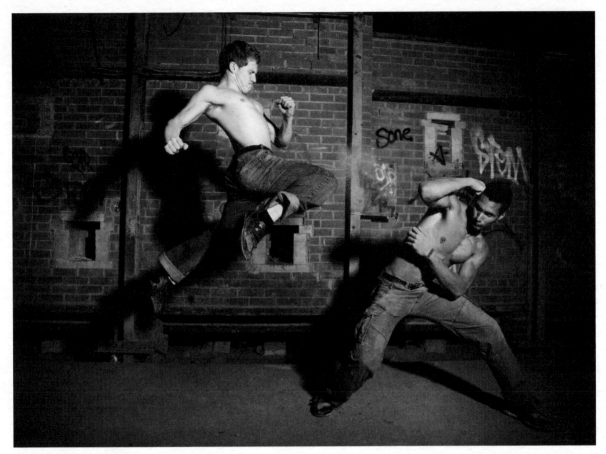

ISTOCK.COM/ARSENIK

1| Gather Reference Photos

Gather several photos of people in motion. I recommend searching the Internet for images of athletes from nearly any sport or performers such as dancers, actors or acrobats. You can also find great dynamic action in movie stills, comic books and concept art for video games. Whatever piques your interest is what you should use. Print out at least ten images. (These will also be used in future exercises, so save them.)

2| Trace an Armature

Place tracing paper over the image and draw an armature of the pose. Use a light table if needed.

3| Draw Armatures

Once you can distill the armature from a pose by drawing on top of an image, you are ready to create armatures through observation. Use the photos you collected as references, but this time don't draw on top of the photo. Pay close attention to the size of the head compared to the body and the lengths of the limbs. Try to render the proportions as accurately as possible.

Extra Credit

Take your sketchbook to a place where people gather and try to re-create people's poses in armature form. I recommend you go somewhere people don't move around too much, such as a coffee shop. You can capture the poses of people standing in line, sitting at a table and interacting with other people. If you don't want to draw in public, draw from what you see in a movie or TV show.

ARMATURE IN MOTION

A great way to practice the armature is to give it something to do. This armature is hoisting a heavy sack onto his shoulder. In each of the drawings, I had to consider how he would move and how he would stay balanced. It helps to act out the motion yourself before getting your armature to do the same motion on the page.

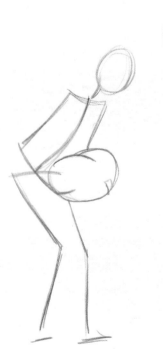

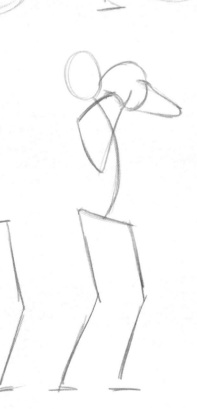

EXERCISE

Stop here and choose one of the armatures you drew from a reference. Picture in your mind the motion the person was going through when that image was captured. Act it out if you can. Now try to draw armatures that animate the motion before and after the moment you drew in the picture.

GESTURE DRAWING

The armature is good for analyzing the pose and clearly defining how the body is positioned. The biggest shortcoming of beginning a drawing with an armature is that it is rigid and slow to get down on paper. Gesture drawing is an even quicker way to convey the movement and flow of a pose while still clearly showing how the body is positioned. You need the skills of armature drawing even though you're not actually putting it down on paper.

Gesture drawing isn't about drawing a skeletal structure or the body's contours; it's about capturing the totality of the pose as one fluid drawing. That means you may mark the twist of the spine or the outside curve of the hips, but you're not thinking about those individual pieces as much as you are trying to capture the energy of the total pose. It still needs to give you all the positional information that the armature did, but it also needs to give you a feeling for the whole subject— not just how everything fits together but also the attitude and energy of the person you're drawing.

You can see the difference between the armature and the gesture in these two drawings of the same pose. Both show how the body is positioned and the proportion of the figure, but the gesture gives a sense of rhythm and flow. You may use a dark line to emphasize the stretch at the hip or the twist through the torso and lighter, smoother lines on a relaxed arm. These initial observations, recorded in your gesture drawing, will come through as the drawing develops and help to keep the energy and emotion through to the final rendering.

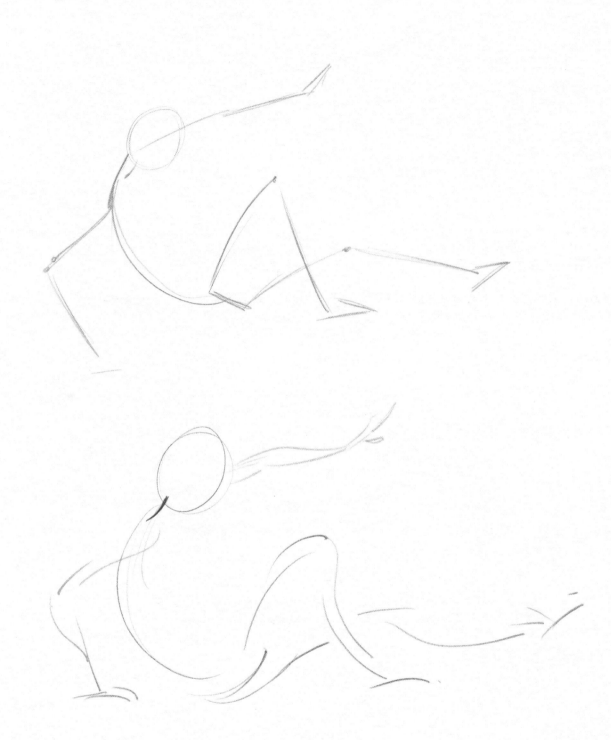

The fluid marks of a gesture drawing allow you to more easily make adjustments as you develop your drawing. It is also easier to integrate the gesture drawing into the more complex drawings you'll learn later. An armature is stiff, and the straight lines are more noticeable than the organic lines of a gesture drawing.

GESTURE DRAWING

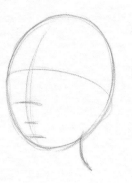

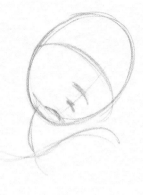

1 Draw the Head and Face Map

As you did with the armature, start your gesture drawing with a circle for the head. Use an eye and face line to indicate the tip and orientation of the head.

2 Add the Neck and Shoulders

Use fluid lines to show the movement of the neck and shoulders.

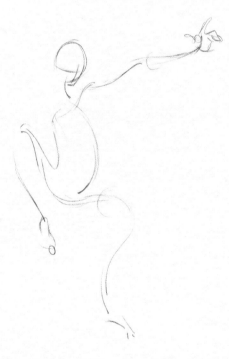

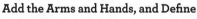

3 Draw the Torso and Legs

Work your way down the body through the torso, hips, legs and feet. At this point, it should be clear that you're not drawing the armature but capturing the movement of the body. One line may represent the outside edge of the body. Another line may indicate a twist of the torso or how one body part flows into the next. You are not drawing any anatomical part of the body in particular. Instead, you're capturing a sense of the whole pose. You will still use the knowledge of proportion and your observation skills of the shifting body, shoulders and hips that you honed when drawing the armature.

4 Add the Arms and Hands, and Define

Go back up to the top and add the arms and hands.

If you'd like to define the body a little, you can add lines around the body similar to the one that shows the volume of the head. These lines can help show direction and volume of the body.

GESTURE DRAWING

Gesture Examples

In the gesture drawings on this page you can see how some drawings emphasize one thing important to the pose, while other drawings hint at it or leave it off completely. For example, some drawings illustrate the hands more clearly because they're an important part of the figure's attitude, while they're de-emphasized in other drawings because they're not as important to the pose.

EXERCISE

Stop here and pull out the photos you chose when practicing the armature. This time practice drawing gestures. Remember to keep the drawings loose and free. Focus on capturing both the pose and the energy of the model. Notice how much faster a gesture drawing can be created than an armature.

LEVEL UP CHECKLIST

Before you move on to the next chapter you should master the basic skills highlighted in this chapter.

- ☐ Draw a simple circle, add an eye line around its circumference to make it a sphere and mark off the chin, nose and mouth.

- ☐ Render a figure as an armature in a variety of poses.

- ☐ Use the technique of gesture drawing to show the movement and flow of a figure.

SIMPLIFIED SKELETON

Once you've mastered drawing the figure as an armature, you can expand on those skills to draw a simplified version of a skeleton. Think of the skeleton as the armature with more dimension. The line of the spine, the angle of the hips and shoulder and the positions of the arms are exactly the same as the armature. Now you'll add a spherical shape for the rib cage, a modified box for the pelvic area and some bony shapes for the limbs.

Remember, at this stage you don't need to worry about the anatomical accuracy of the bones. For now, just create something that has a little more three-dimensional volume than the armature. This will give you a greater understanding of the structure below the muscles. You can, of course, study the actual bones of the skeleton if you want your drawings to be more anatomically accurate, but at this stage it's not necessary.

HEAD AND NECK

For your armature you used just a sphere to represent the head. Now you'll get a little closer to drawing an anatomical skull by drawing a simplified head shape based on the sphere.

There are two parts to this simplified skull: first, the cranial area, which is a wide sphere at the back of the head. Second, the face area joined to the cranium. It can be drawn as a second oblong sphere or as a squared-off mask attached at the front. The main thing to convey is that the face area is narrower and drops down from the cranial sphere.

The spine connects to the skull at the bottom of the cranium, near the back, and has a gentle backward curve.

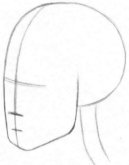
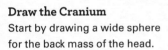

1 Draw the Cranium
Start by drawing a wide sphere for the back mass of the head.

2 Add the Face
The face drops down from the cranium and is a little longer. Add in the centerline, and add marks for the nose and mouth.

3 Add the Neck
The neck connects to the cranium just behind the jaw. Instead of the line you'd see on an armature or gesture drawing, use a cylinder to give it dimension.

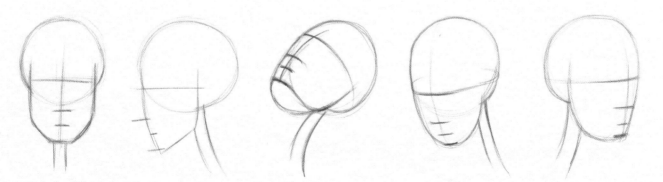

These heads are similar to the simple sphere heads in the Armature lesson (pages 10–11) except they are a bit closer to the real anatomical shape of the skull. The neck is now a cylindrical shape instead of just a line.

RIB CAGE AND SPINE

What you're trying to accomplish with the simplified skeleton is a drawing that shows the volume of the underlying structure of the body. It's too easy to lose sight of the volume when you're focused on small details. This is especially true for the rib cage. If you start drawing the individual ribs, you'll likely lose sight of the three-dimensional shape of the rib cage as a whole.

So forget about each individual rib and draw the rib cage as an egg shape.

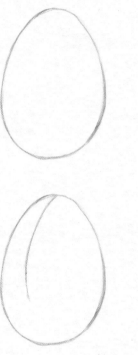
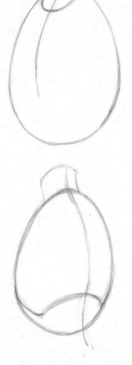
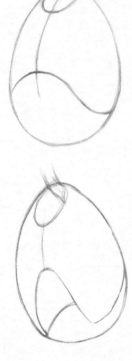

1 Draw the Rib Cage Shape
The rib cage is narrower at the top than you probably realize because when you look at a person you see the muscles of the chest and back squaring off the shoulders. When you look at a skeleton, you realize how narrow the rib cage gets at the top to make room for the clavicle and scapula. Remember, even though this looks like a circle on the page, you need to think of it as a three-dimensional shape, like an egg.

2 Add Anatomy
When you draw the shape of the rib cage's arch consider how you would draw on top of a three-dimensional shape. It's similar to drawing the eye line on the armature face map, but it curves around the shape.

3 Add the Neck
Draw a hole in the top front of the form for the opening of the neck.

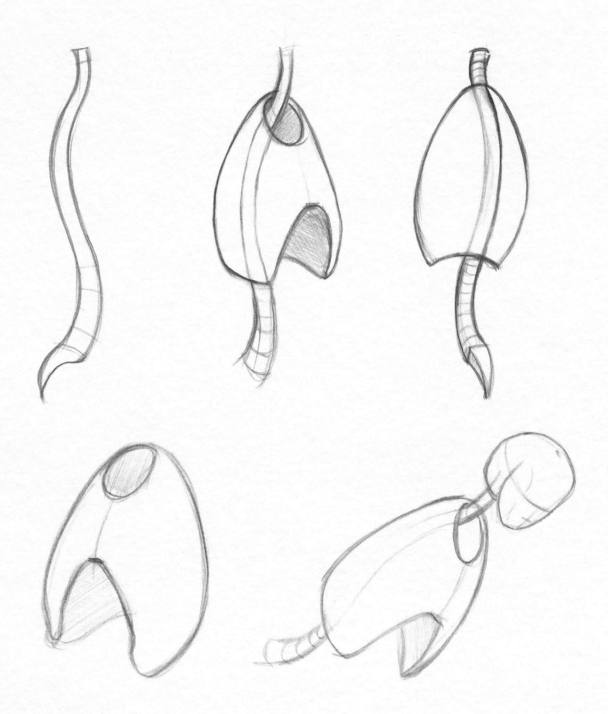

4 Draw the Spine

Once you have a handle on drawing the rib cage as an egg shape, you can enhance the form to look more like the actual shape of the rib cage. The spine runs through the back of the rib cage. Practice drawing the rib cage and the spine from all different angles.

THE CUBE

Like the sphere, the cube is a basic building block in art. Being able to draw a box well opens up a whole new dimension to your skill. Because the box has clearly defined edges and planes, it has a strong illusion of depth. When you see a cube shape, your mind automatically sees it in three dimensions rather than just lines on a flat surface. Artists exploit this trick of the eye to create works of art that appear to leap off the page.

Practice drawing boxes in a variety of shapes and sizes. Long, skinny boxes. Wide boxes. Tiny boxes. Even boxes with transparent faces so you can see the back corner that's usually hidden. Mastering this skill takes you a long way to creating art with real depth.

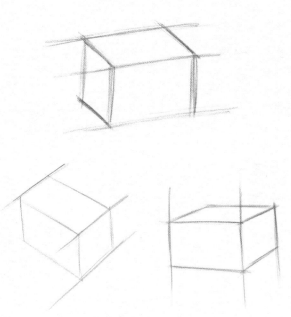

When drawing the cube, don't worry about perspective or vanishing points. Every edge that faces the same direction should be drawn with parallel lines.

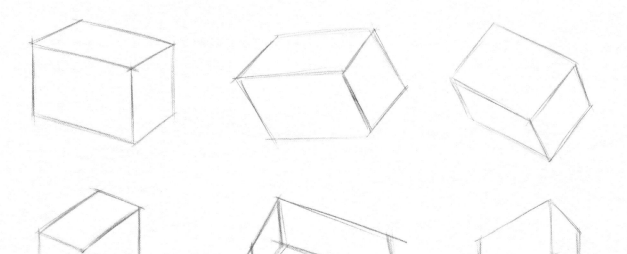

LOWER BODY

The torso is made up of two major masses: the rib cage and the pelvis. The rib cage is an egg-shaped form. The pelvis, when you consider both the bones and the muscles in the area, is a more squared off shape. Simplifying the forms this way makes it far easier to move the torso area around in your mind. In later chapters you'll add the connective muscles between the two forms. For now, having a clear understanding of how these underlying structures move in relation to each other is vital to giving your figures a believable sense of dimension and allows you to pose your figures more clearly.

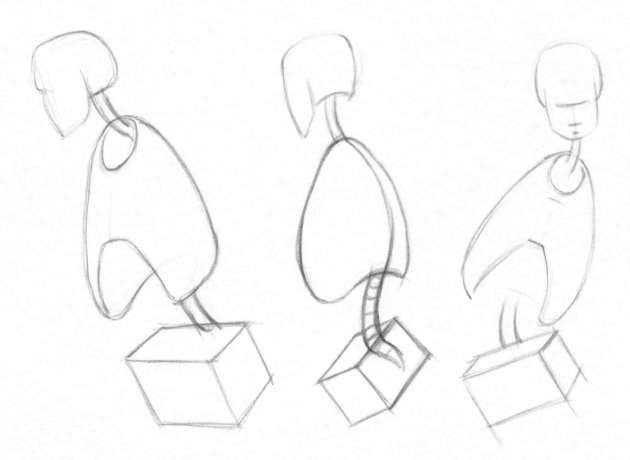

1 Draw the Pelvis

The box does a fine job of representing the pelvic area because it clearly defines the direction, angle and tip of the hips. Don't worry that the real-life pelvic bone doesn't look much like a box. Once all the muscles and skin are added, the bowl shape of the pelvic bone is totally obscured. You're not going for anatomical accuracy at this stage; you simply want to create a foundation to build a three-dimensional figure.

2 Draw the Legs

Bones of the arms and legs are long cylinders with a thicker portion at each end. The femur of the upper leg has a round head at the top that protrudes outwardly as it meets the hip. You will have to taper the box shape of the hips to fit the head of the femur in the right place. The leg bone doesn't just drop straight down; instead it moves closer to the center at the knee where it sits atop the tibia. The tibia is flat and wide at the top and narrower at the ankle. The fibula nestles in along side the tibia and is the outside bump on our ankle.

Again, your goal isn't anatomical accuracy but a reasonable approximation of the scaffolding that holds up the muscles. The more you study the anatomy, the more accurate the shapes will be, but I don't want you to get caught up trying to get every detail exactly right. You're still building your foundational skills, so practice until you get a handle on the basic shapes and forms. Don't let perfection keep you from moving forward. You're aiming for more than just an armature made of tubes, but you aren't trying to illustrate a reference manual for doctors.

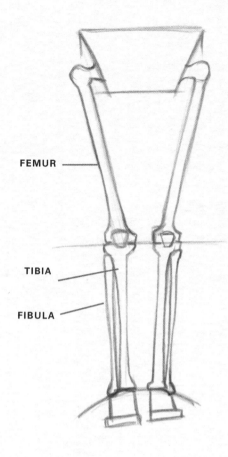

FEMUR

TIBIA

FIBULA

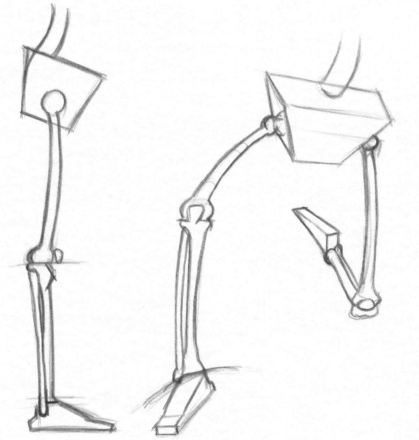

Practice moving the legs around while also shifting the hips up or down. Also work on foreshortening the bones as they move toward or away from you.

3 Draw the Foot

This simplified foot is built in two parts. The top portion is a wedge shape that represents the thick bridge of the foot. It sits upon a long narrow box that represents the toes, heel and pads of the foot. Since it's based on box forms, you can clearly see the volumes and angles of the foot. It looks like a blocky shoe, which is a good foundation to build more specific anatomy onto later.

Stop here and get a shoe, preferably a loafer with no laces, and use that as a general reference to draw the wedge-shaped foot. On most shoes you can clearly see the angle of the upper foot (where the laces would normally be) meeting up with the horizontal section for the toes.

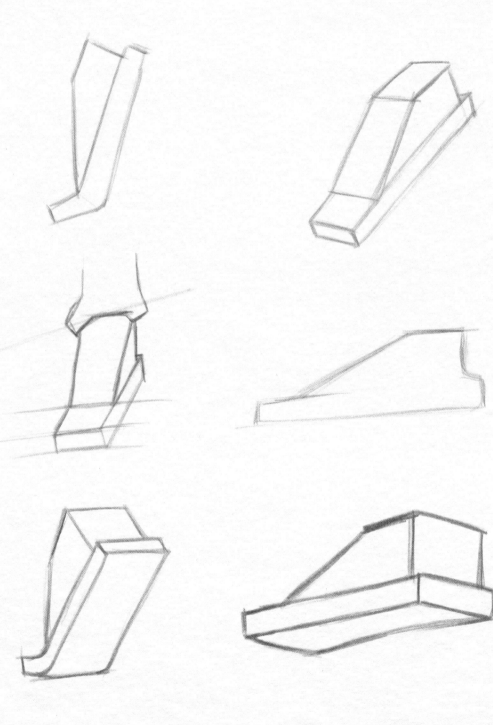

SHOULDER GIRDLE

The shoulder girdle is made up of the clavicles in front and the scapulae in back. Together they encircle the rib cage and work together to attach the humerus (upper arm bone) to the rib cage. They also give the arm range of motion at the shoulder.

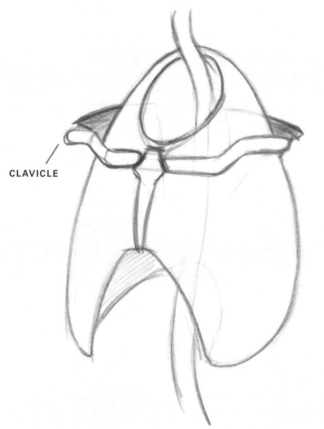

CLAVICLE

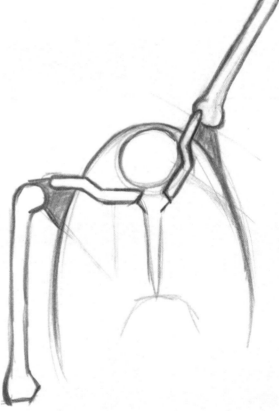

1 Draw the Rib Cage and Clavicle
Start with a rib cage and add a clavicle. The clavicle starts at the breastbone and stretches out to the shoulder in an S-shape. The bone stays in place at the breastbone in the center of the rib cage but moves up and around where it meets the arm at the shoulder.

2 Draw a Raised Arm
When the arm is raised, the clavicle pivots up with it. You can see how the S-shape of the clavicle wraps around the neck.

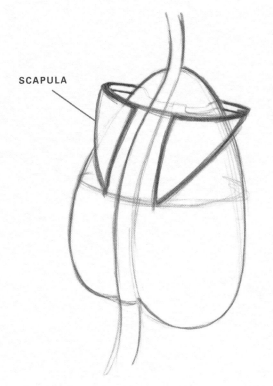

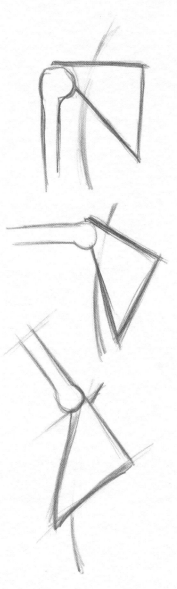

3 Draw the Scapula

Add a scapula on the back of the rib cage. The scapula is roughly a triangular shape that reaches around the back of the rib cage out to the shoulder. It attaches to the humerus and is connected to the back by several muscles.

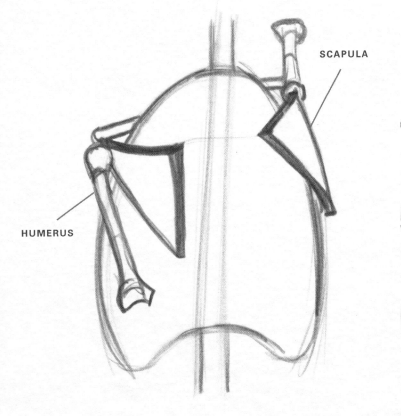

SCAPULA

HUMERUS

4 Draw an Outstretched Arm

When you raise your arm to the side, the scapula rotates away from the spine.

5 Draw a Lifted Arm

When you extend your arm in front of you, the scapula moves toward the side of the rib cage.

6 Add the Upper Arm

The humerus is a relatively straight bone. It has a ball head where it meets the shoulder girdle, and it widens at the elbow.

FOREARM

The two bones of the forearm—the radius and ulna—work together to give your hand its range of motion. They are designed to twist around each other so you can rotate your hand. When your arm is stretched in front of you and your palm is facing up, the bones are side by side. When you rotate your hand so your palm is facing down, the bones are crossed.

The ulna is the bone you feel at your elbow when your arm is bent. The ulna is widest at the elbow and tapers toward the little finger.

The radius is the opposite of the ulna. It is narrower at the elbow and gets wider at the wrist.

RADIUS

ULNA

1 Draw the Radius and Ulna
Draw in the radius and ulna as boxy forms to more clearly show how they taper or widen from the elbow to the wrist.

2 Twist the Radius and Ulna
Draw the arm twisted with the hand face down to show how the bones overlap.

3 Draw the Elbow
The ulna is the bone you feel at the end of your elbow. The humerus (upper arm bone) widens at the elbow and the ulna fits in and around it. You can draw this union as if the ulna slips into the humerus like two pieces of wood slotted together.

HAND

The hand can be complicated to draw because the fingers move in so many different ways. To simplify the hand, you can think of it like a mitten and treat the fingers as one solid mass.

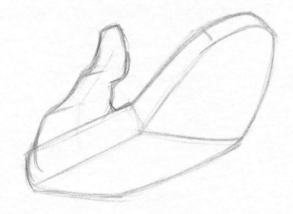

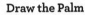

1 Draw the Palm
Start by drawing the palm as a flattened box shape that tapers out from the wrist and peaks in the middle.

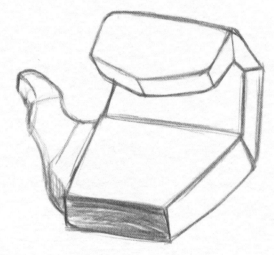

Even though you're grouping the fingers together, you can still pose your hand in a wide variety of ways and use it as a reference for your drawing.

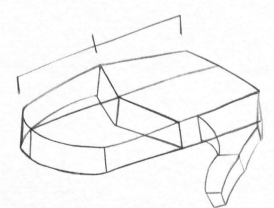

2 Draw the Fingers and Thumb
Attach a similarly sized shape to the front of the palm that tapers in for the fingers. You can angle or bend the finger mass as desired. Add a thumb shape off the side of the palm.

EXERCISE

Stop here and grab a mitten, if you have one, or pull a short sock over your fingers on your nondrawing hand. Pose your hand in different ways and draw it using only blocky shapes.

USE PHOTOS TO DRAW A SIMPLE SKELETON

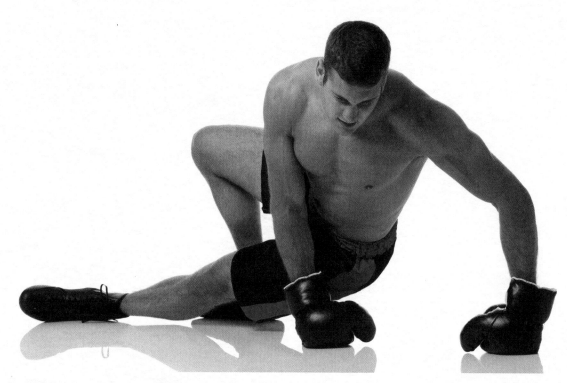

ISTOCK.COM/4X6

1| Find Reference Photo

Find a photo of someone who is posed in an extreme way—someone posed with a strong twist or bend in the torso and arms and legs in motion. Parts of the body will likely be foreshortened.

2| Draw Armature or Gesture Drawing

Lightly draw the pose as either an armature or as a gesture drawing. Do not trace the image; figure it out for yourself through careful observation.

3| Create Skeleton on Top of Sketch

Re-create the whole pose as a simplified skeleton by drawing on top of your armature or gesture drawing.

LEVEL UP CHECKLIST

Before you move on to the next chapter you should master
the basic skills highlighted in this chapter.

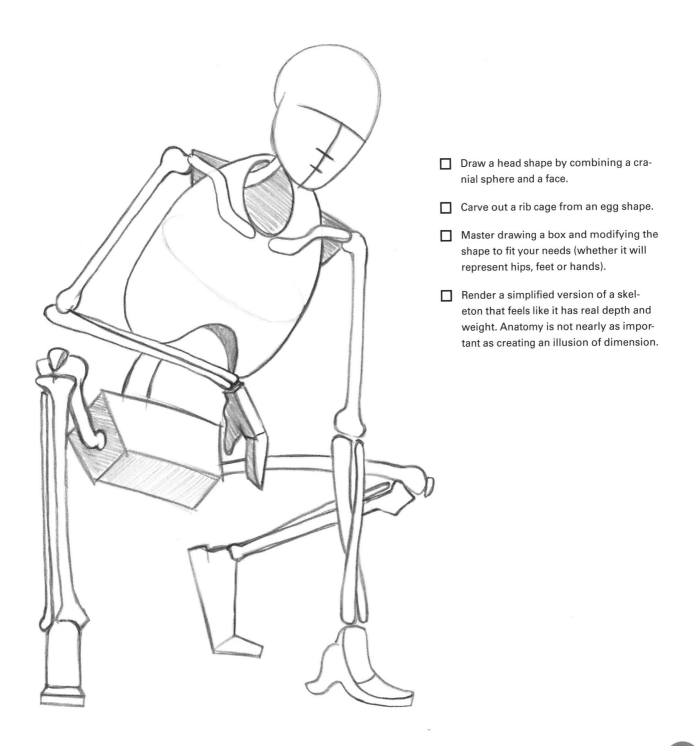

- [] Draw a head shape by combining a cranial sphere and a face.

- [] Carve out a rib cage from an egg shape.

- [] Master drawing a box and modifying the shape to fit your needs (whether it will represent hips, feet or hands).

- [] Render a simplified version of a skeleton that feels like it has real depth and weight. Anatomy is not nearly as important as creating an illusion of dimension.

SIMPLIFIED VOLUMES

The next step in understanding how to build a figure is to flesh it out three-dimensionally. The skeleton underpins the form, but it's the flesh and muscle that give the body its shape.

If you become adept at drawing the sphere, box and cylinder, you can bend, merge and sculpt them into any form you desire. While I'm focusing on drawing people, these skills apply to all representational drawing. You will learn to look at an object and break it down in your mind into a series of basic volumes all merged together. It doesn't matter what your subject is—a flowerpot, a car, a kitten or a person can all be broken down into a series of simple volumes. Of course, the more you understand about what you're drawing, the more accurately you can sculpt the shapes into what you want them to be.

Cartoon characters are good examples of using simple volumes to build a subject. Mickey Mouse is largely built from bubbly spheres. SpongeBob is pretty much a box with arms and legs. Using simple volumes for cartoons not only makes them easier to draw and move but also gives them clarity and dimension. When drawing more realistically, your shapes will be more intricate, but they should still retain the clear three-dimensionality of the basic volumes.

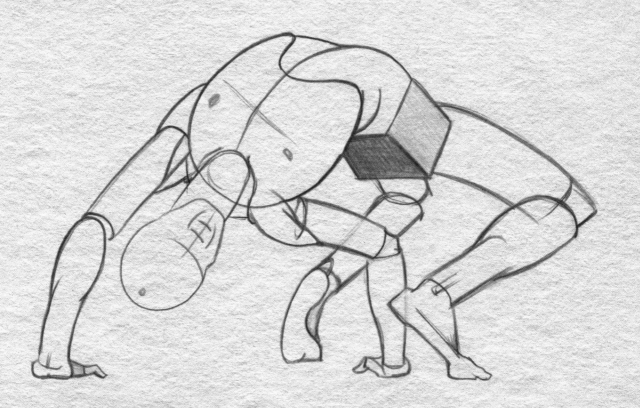

SCULPTING FORMS

Playing around with three-dimensional forms is fun. You don't have to worry about making them look like something specific. Make a box stretch or twist. Smash a ball or cut it in half. Poke holes in a pyramid. Break apart a cylinder. Make a box look flabby. Make a sphere look sad. Try to give the shapes personality and a feeling that they're in motion.

Please don't skip over this lesson: It's essential to the rest of the chapter and, really, to all of drawing. If you can master making shapes appear to have dimension on the flat page, you will be well on your way to being an excellent draftsman. These skills are expanded upon in the sections on Merging Forms (pages 40–41) and Cylindrical Forms (page 44).

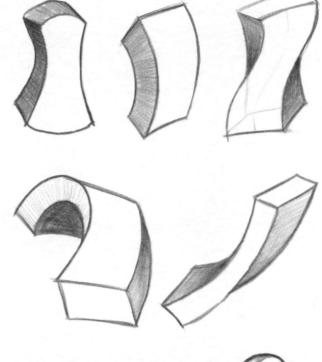

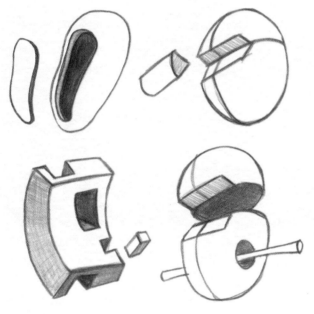

After you're comfortable getting your shapes to bend and stretch, you can make them interact. You can punch holes in them, have other shapes pass through them, or break them into pieces. Keep playing around with the shapes and discover all the different things you can get them to do.

EXERCISE

Stop here and search the Internet for images of abstract sculpture. Many abstract sculptures are forms and volumes that have been bonded and twisted together. They may simplify the human form, represent an abstract thought or strive to evoke a feeling. Find some examples that you like and draw them. Do not draw them in an effort to copy the photo but to re-create the shapes as they sit in space.

HEAD SHAPES

You can see how the heads on this page are more defined versions of those in the Head and Neck demonstration (page 23). They still have the cranium in back and the face attached at the front, but they are more cohesive forms. Instead of just a line indicating the eye line, a wedge shape has been cut out for the brow and eye region. The mouth is built on top of a saucer shape attached to the face. The jawline has a distinct edge and clearly shows thickness. Drawing the head this way uses the exact same skills you practiced on the previous page. You're putting together modified boxes and spheres in a way that represents a human head.

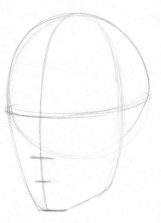

1 Draw a Spherical Head
Start with the simplified interlocking spheres from the Head and Neck demonstration (page 23).

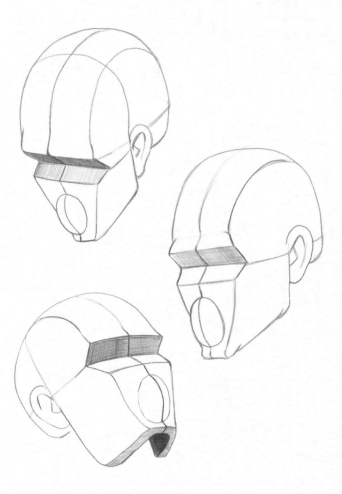

3 Merge Sphere and Box Shapes
Merge the spherical head and the box head into a head that has both round areas and hard edges. Use a saucer shape for the mouth area. This approximates the muscles of the mouth and the way the mouth area is pushed out by the teeth.

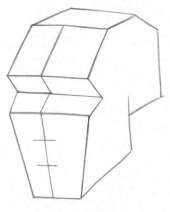

2 Draw a Box Head
Draw the same head with boxes.

NECK

The neck is generally built from a cylinder. There are additional muscles that come from the jawline and attach to the neck (at the hyoid bone). The overall neck has a gentle concave curve that is obvious in profile. This curve varies from person to person and can be quite pronounced on people with poor posture.

Start by drawing the head using simple spheres and a gesture line for the neck. Then build up the dimensional properties by defining the edges and the planes of the head and how they sit in space. Add in the neck as a cylinder, basing it off the gesture line you established. Connect the jaw to the neck.

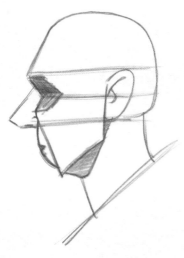

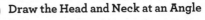

1 Draw the Head and Neck Shapes
Start by drawing the head. Add in a simple cylinder for the neck that connects to the back of the skull and about halfway on the underside of the jaw. Then connect the underside of the chin to the cylinder of the neck.

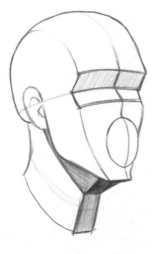

2 Draw the Head and Neck at an Angle
Now draw the head from a three-quarter view and add in the cylinder and area under the chin. You can square it off in the front to help define the three-dimensional qualities.

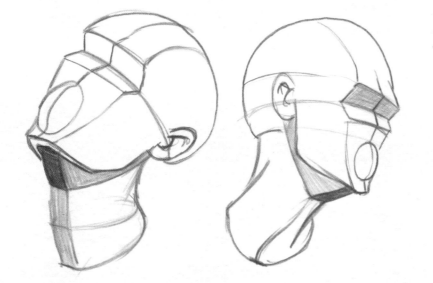

3 Move the Head
When drawing the head and neck with movement, you may want to start by drawing the head using simple spheres and a gesture line for the neck. Then you can build up the dimensional properties using simple forms. You can use the same techniques from the section on Sculpting Forms (page 37) to show the neck twisting, stretching or compressing.

MERGING FORMS

Expand on the skills you learned in the Sculpting Forms section (page 37) by merging forms. Merging forms allows you to create more complex structures by connecting two or more spheres, boxes or cylinders.

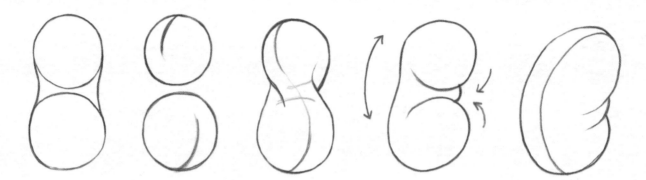

1 Draw Stacked Forms
You can merge forms by connecting them as if they were in a sack or by squashing the two parts together.

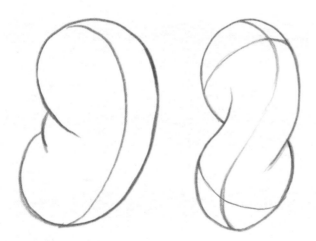

2 Move Merged Forms
Once you have two forms merged, start playing around with moving them. Figure out how to twist, bend, squash and stretch your new form.

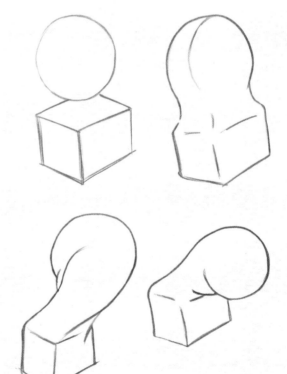

3 Move and Merge More Forms
Choose other simple forms to merge and move.

4 **Create More Complex Forms**
You can combine different forms in countless ways. For example, the forms can connect edge to edge, one can poke out or pass through the other or one could just blend or melt into another. The point is to start creating more complex forms built from the simple forms you already know how to draw.

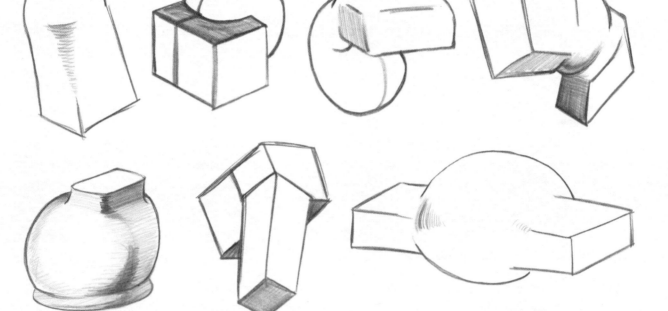

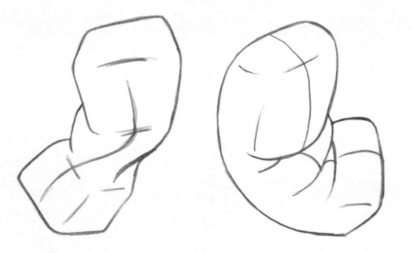

EXERCISE

Animated characters are built by combining basic forms like these. Find images of your favorite characters and deconstruct them to discover their simple shapes. To see some examples, search the Internet for "character sheets" of classic Disney characters (such as the dwarfs from *Snow White and the Seven Dwarfs*, Mickey Mouse or Donald Duck), any of the Warner Brothers characters or your favorite cartoon.

CHEST TO HIPS

The torso is made up of the rib cage and the pelvis. It's not unlike an egg connected to a box in a sack. You will use the same skills you used to merge forms to create a torso. Again, you're not going for the actual anatomy of the torso at this point, only the basic three-dimensional shapes of the simplified body.

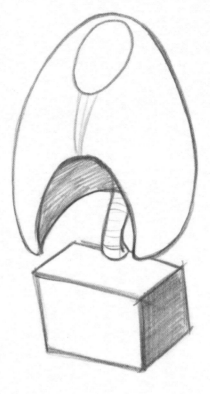

1 Draw the Torso and Midsection
Start with the simplified skeletal torso from the Rib Cage and Spine demonstration (page 24) and a box for the midsection.

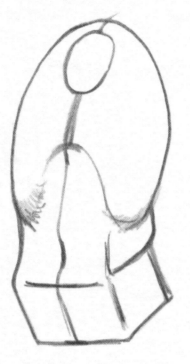

2 Merge the Shapes
Now merge the forms. Approximate the muscles by connecting the rib cage to the hips with an abdominal sheet in front, flanks at the sides and two wide muscles on each side of the spine. You should start to see how the body is made up of simpler parts merged together into a more complex form.

3 Move the Torso
Practice twisting, bending and stretching the torso to an extreme until it starts to look anatomically impossible.

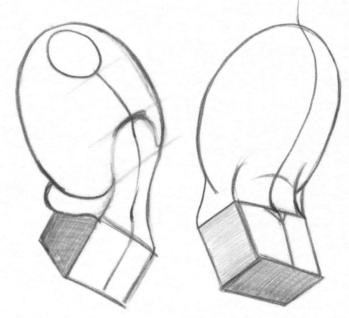

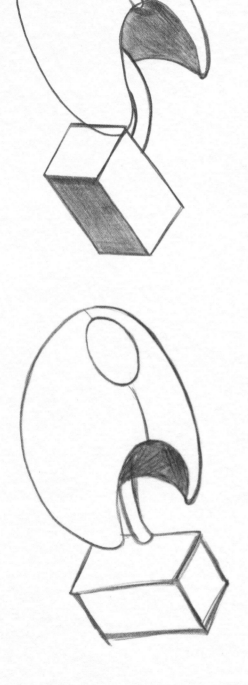

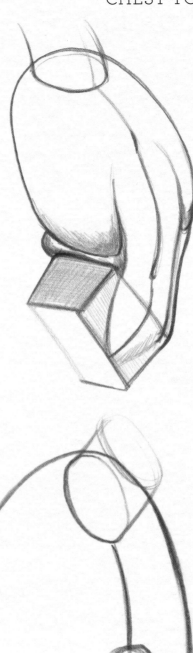

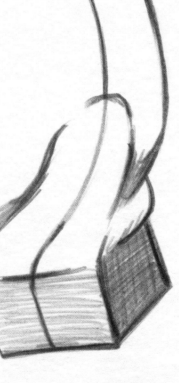

Here are a couple of examples of the simple skeleton merging into a simplified torso. The skeleton is the hard structure of the body, and the muscles are the softer forms that flex and stretch as the body moves around.

CYLINDRICAL FORMS

The cylinder is a useful form in drawing. It's a great foundation for legs, arms, fingers and a number of other things. It's also extremely useful when trying to figure out how to draw something that is foreshortened because it's far easier to rotate a cylinder in space and build anatomy on top of that than it is to figure out what muscles look like from a difficult perspective. The top and bottom of a straight cylinder are circles. If the bottom were facing straight toward you, all you would see would be a circle and the rest of the shape would be hidden behind it. As the cylinder pivots up or down, the circle becomes more and more oval until it becomes a straight line. Both the top and bottom circles are exactly the same shape, and they're connected at the sides by a straight line. When you're drawing a cylinder, go beyond the two-dimensional shapes to capture the three-dimensional form.

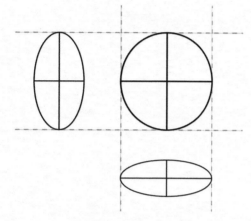

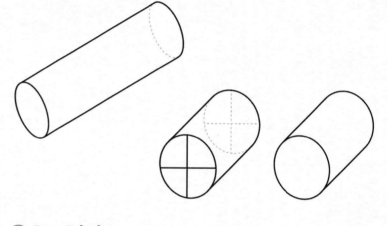

1 Draw a Circle in Perspective
When a circle tips away from you, the width of the circle stays the same but the edge turning away gets shorter.

2 Draw Cylinders
On a straight cylinder, the ellipses on both ends will be the same size and angle.

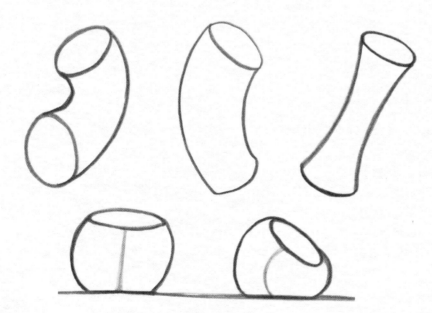

3 Bend and Move the Cylinders
Once you can draw a straight cylinder well, start molding and bending it into different shapes. Bend it into something that looks like a macaroni noodle. Twist it. Compress it. Stretch it. Give it the same treatment you did in the Sculpting Forms (page 37) and Merging Forms (pages 40–41) sections.

LOWER BODY

Cylinders are perfect for blocking out the space for legs. Using the simplified skeleton as a foundation, the cylinder for the leg begins at the top of the femur. Feel your own hip bone to see how close the head of the femur is to the skin. The outside edge of the cylinder should start there and taper down to the knee.

At the top of the thigh, additional muscles are used to pull the legs together. They start near the pubic area and stretch to about halfway down the side of the thigh.

The lower leg tapers more dramatically and has a bit of a curve at the front because of the shape of the shin bone (tibia). It widens at the back for the calf muscles.

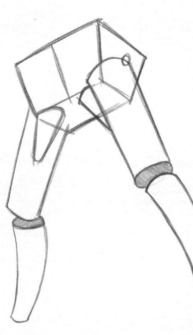
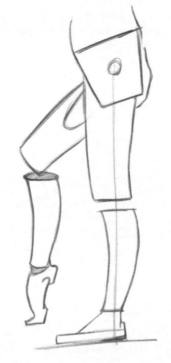
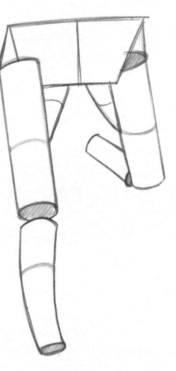

1 Draw Legs

Starting with a box for the hips, add a cylinder for the thigh. Add a tapered cylinder from the pubic area to about halfway down the thigh. Then add another cylinder for the lower leg. The lower leg narrows at the ankle, so taper the cylinder near the foot. You can also add some curvature to the cylinder so that it arches a bit toward the back and away from the center of the body. This replicates the real shape of the anatomy.

EXERCISE

Find images of animals and draw them as a series of simple shapes. Giraffes, gazelles, tigers, bears, octopi or whatever animal you can think of make great subjects. Use spheres, boxes and cylinders to create your simplified animal.

2 Draw Knees

When joining the cylinders of the upper and lower leg, you can merge the volumes with a square hinge for the knee. The way the ends of the humerus (upper leg) and the tibia (lower leg) meet creates a fairly blocky structure. Using the box helps to define the front plane of the knee and further clarifies the orientation of the leg in three-dimensional space.

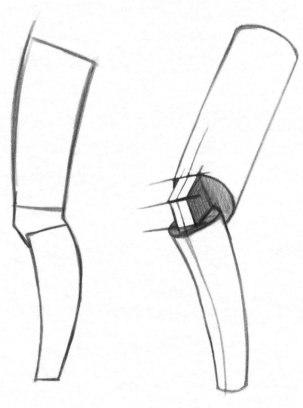

In direct profile, the cylinders of the leg may appear to be squares, but you still have to think of them as three-dimensional forms that have depth and mass. Also notice the simple curves and tapers the cylinders take to roughly follow the muscles of the body.

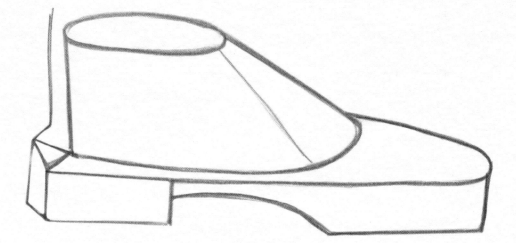

3 Draw Feet

The foot is a complicated structure. These illustrations are designed to clearly show the thickness and structure of the foot. Often feet are drawn too flat or without any definition.

The foot can be broken down into two main parts: the top arch and the toes and pads. The top arch is steeper on the inside of the foot and flattens out as it fans out toward the front of the foot.

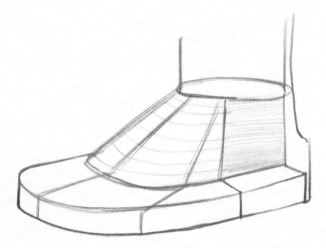

The bottom portion of the foot is flatter and is longer at the big toe.

The bottom of the foot has a big pad at the heel and at the front of the foot under the base of the toes. The inside of the foot arches between these two pads.

ARMS AND HANDS

The arm has a significant range of motion, which can make it difficult to draw in its many positions. This is why breaking it down into simple forms is so important. If you can get your simplified forms in the right positions and in the right proportions, it will be far easier to figure out the anatomy as you develop your drawing.

Like the leg, the arm is made up of long cylinders. The upper arm is capped with a wedge-shaped shoulder muscle that connects the arm to the body. This muscle extends halfway down the upper arm. The lower arm is another cylinder that bulges nearer the elbow. At the wrist, you can square off the cylinder to clearly show how the forearm is rotated.

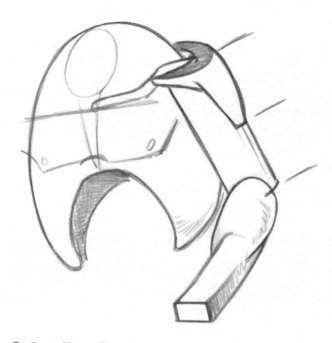

1 Draw Upper Arms
Start with a cylinder where the clavicle and scapula meet at the side of the rib cage. The upper arm extends almost to the bottom of the rib cage. You can mark the midway point of the upper arm so you'll know where the shoulder muscle connects.

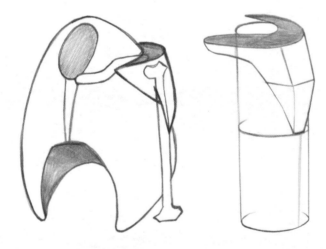

2 Draw Shoulders
The upper arm is capped by a wedge-shaped shoulder muscle that helps tie the arm to the torso. It connects to the clavicle in the front, the scapula in the back and about halfway down the humerus bone. The shoulder is what gives the upper torso its width. The upper part of the rib cage is fairly narrow but the muscles of the shoulder square off this area.

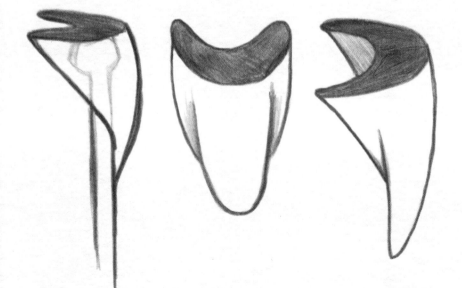

3 Draw Lower Arms

The forearm is a more complicated shape. It starts at the elbow as a cylindrical shape before bulging out and then narrowing again, and finally ending with a box shape at the wrist. The box is useful because it shows how the forearm is rotated. You can refresh your memory about the rotation of the radius and ulna bones in the Forearm demonstration (page 32).

Anatomically there are three parts to the deltoid, but they all work together to elevate the arm. The middle deltoid (medial) overlaps the front (anterior) and back (posterior) sections. Together they form this curved wedge that caps the upper arm.

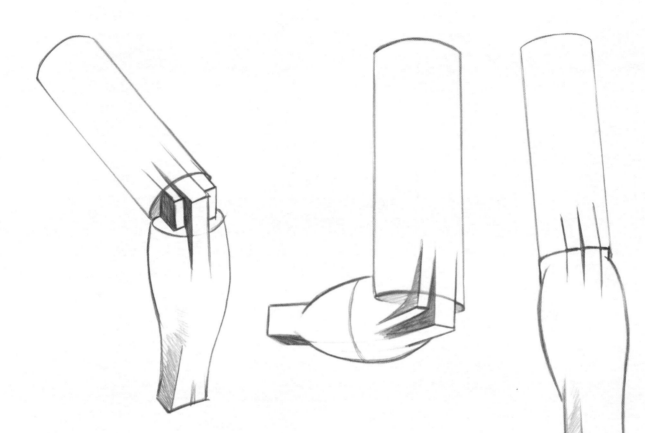

4 Draw Elbows

Like the knee, the elbow can be represented by a box-shaped hinge. Unlike the knee, however, the elbow appears to have three hinges. The main center hinge, noticeable when the elbow is bent, is the top of the ulna bone in the forearm. The two smaller box shapes on each side represent the bottom of the humerus bone in the upper arm. Think of the two outer edges of the elbow as one box and then draw a thinner box on top of that for the center of the elbow. When the elbow is bent, the edges are offset, but when the elbow is straight, they line up.

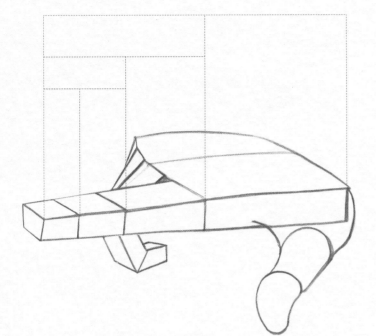

5 Draw Hands

In the Hand demonstration (page 33), you simplified the hand to a boxy mitten. Now you can break the fingers apart using more boxes. At this stage, the box form really makes you focus on how the finger is oriented. It will make adding knuckles and fingernails much easier later on.

As for the proportion of the hand, the first set of knuckles is halfway from the wrist to the tip of the fingers. The second set is halfway from the first knuckle to the end of the finger. And the outermost knuckle is halfway from the second knuckle to the end of the finger.

EXERCISE

Stop here and take some time to observe your own hands. Look how the fingers bend at the joints and how the skin folds. Notice the range of motion of your fingers and thumb, and all the different ways they can be posed. Your hand can be made into a fist like a weapon, or it can delicately hold something fragile. It can be used as a tool or to accentuate expressive speech. Observe both the construction of the hand and how it moves.

USE PHOTOS TO DRAW SIMPLE VOLUMES

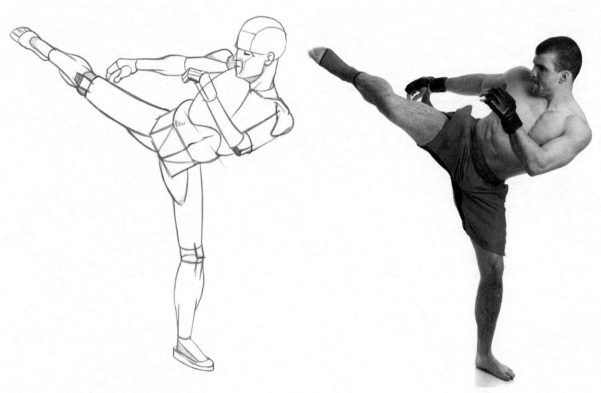

ISTOCK.COM/NICKP37

1| Gather Photo References

Gather the images you printed out for the armature assignment in Level 1 and with the drawings you did of the armatures.

2| Draw Pose Over Photo

Using tracing paper or a light table, draw over the armatures you previously drew and re-create the pose using only simple volumes. Look at the picture carefully to see how the body is positioned while you use your armature as a foundation for your drawing. Pay particular attention to getting the forms to sit in space accurately. If a leg is kicking toward you, make sure the cylinders are clearly pointing toward you as well. If you see that something in your armature drawing isn't accurate, correct it as you build up your new drawing.

Extra Credit

Once you have analyzed a few poses on tracing paper, draw more figures using a photo as reference but don't use anything to aid you behind your drawing. Start with a light gesture drawing and build up the simple volumes from there.

LEVEL UP CHECKLIST

Before you move on to the next chapter you should master
the basic skills highlighted in this chapter.

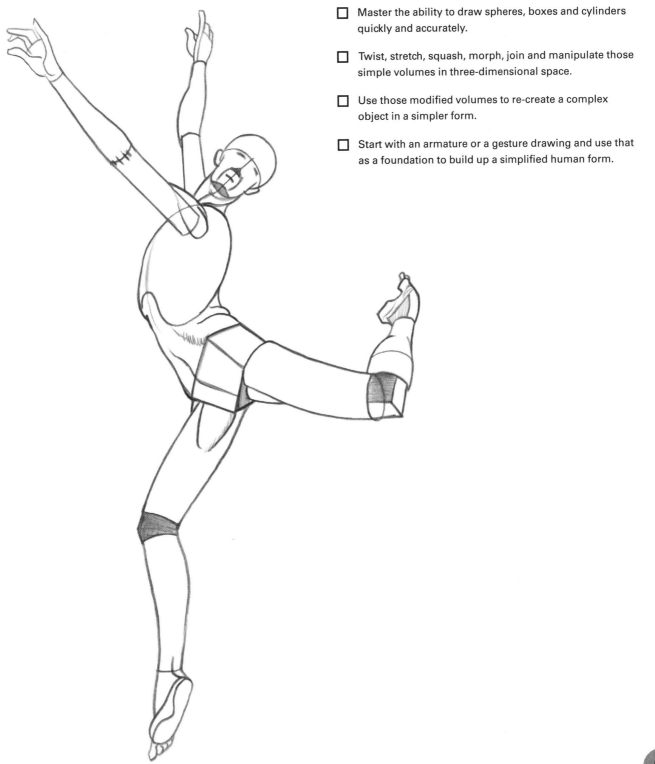

☐ Master the ability to draw spheres, boxes and cylinders
 quickly and accurately.

☐ Twist, stretch, squash, morph, join and manipulate those
 simple volumes in three-dimensional space.

☐ Use those modified volumes to re-create a complex
 object in a simpler form.

☐ Start with an armature or a gesture drawing and use that
 as a foundation to build up a simplified human form.

MAJOR ANATOMY

At this point you should be able to construct a three-dimensional figure out of boxes, spheres and cylinders. There's more than one way to piece those elements together to create a figure. Some figures will call for more block shapes, which creates a sturdier feel, while others might be built from softer spherical shapes. It's up to you to analyze what you're drawing and create a figure using the forms that feel best for your subject.

The approach to adding anatomy to your figures is no different. For example, when you draw the triceps, you're not drawing the striations of the muscle like you'd see represented in an anatomy book. Instead you're drawing the three-dimensional shape of the muscle as it sits on the arm. As you did in Level 3, you'll use a combination of spheres and cylinders blended together to shape the muscle and better define your overall subject in three dimensions. You're not looking at the body as a doctor would, but you're seeing the individual shapes of the muscles and how they fit together.

Of course, the more anatomical knowledge you have, the more clearly you can see and understand your subject. This chapter will give you a foundation for understanding the major anatomical forms of a human. It will give you an approach to drawing anatomy to better define your figures three-dimensionally. However, the body is made up of more than 650 muscles, many of which will never show or will barely make an appearance even on the leanest of people. Your goal for this chapter is to learn how to construct the largest and most visually impactful muscles of the body.

Once you have mastered the major muscles, you can add more. At that point, referring to an anatomy book would be useful to expand your knowledge. See Further Reading (page 127) for a few recommendations.

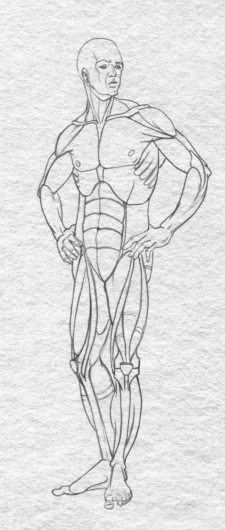

SCULPTING HEAD FORMS

There are many ways to approach drawing the head. What shapes you chose are up to you. Even though individual faces and heads vary greatly, the underlying structures are basically the same. This means you can start your drawing very broadly and get more and more specific to your subject as you develop it.

In the Level 1 Armature demonstration steps 1 and 2 (pages 9–10), you used a simple sphere to depict the head. In the Level 2 Head and Neck demonstration (page 23), you used a sphere for the cranium and attached a face plane to it. In the Level 3 Head Shapes demonstration (page 38), you more clearly defined some of the planes of the head. In Level 4, you'll look at how the features fit into this simplified head.

The simplified planar head is based on the structure of the skull. The skin on the upper part of the face is generally fairly thin, which means the underlying shape of the skull is more prominent. The cheeks and mouth have a lot more muscle and fat, which cover up the lower half of the skull; however, the skull still acts as a foundation that influences the many shapes of the head.

Understanding the relationship between the planes of the face and the underlying skull is important to drawing a realistic head.

EXERCISE

It would be ideal to have a medical model of a skull to work with (you can buy one, but realistic models are expensive). If not, you can work from photos of real skulls taken from different angles. Draw the skull as a series of planes. Pay attention to all the different structures and their angles in relation to each other. You can use lots of planes or fewer, depending on how much you want to simplify the form. You can see other artists' approaches by searching "planar head" on the Internet. This is a similar concept to the Merging Forms exercise (pages 40–41) but now you are analyzing a more complicated subject and translating it into something new based on your observations.

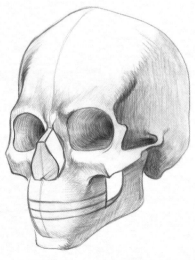 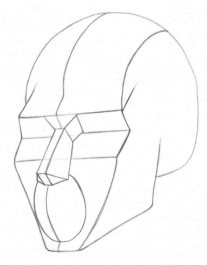 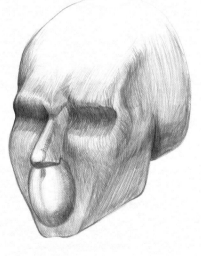

Here you can see the relationship between the simplified planar head, the skull and the featureless head. The simplified head forces you to clearly define the three-dimensional structure of the head. It's based on the underlying structure of the skull and the soft tissue that covers it. Starting with this simpler form makes it easier to add facial features in the correct positions, proportions and perspectives.

EYES

Often when people draw the eyes they're only thinking of the shape of the lids and the round iris, but you need to consider the whole three-dimensional shape of the eye. The eye is a round ball that sits in the socket of the skull. It's surrounded by muscle, fat and skin and is covered by the top and bottom eyelids. Understanding the structure of the eye is important to drawing it in a way that feels real on the page.

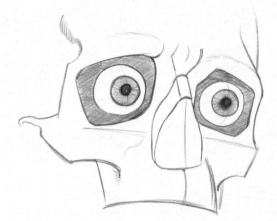

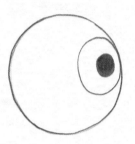

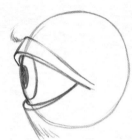

1 Draw the Eyeball
The eyes are spheres that sit in the eye sockets of the skull.

2 Draw the Eyelid
The lids rest on top of the eyeball. They do have some thickness so think of them more like a piece of cardboard than a sheet of paper.

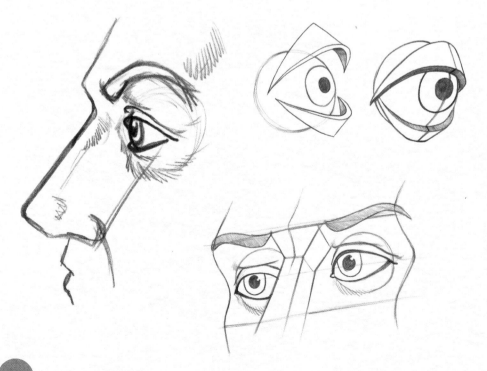

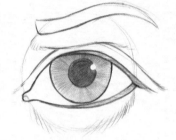

When you're drawing the eye on the face, you have to have a clear understanding of the three-dimensional shape of the head. The eyes need to fit in the planes of the head so they're positioned correctly and in the right perspective. You don't want to just copy the shapes you see—you want to re-create what you see as three-dimensional forms on the page.

3 Draw a Variety of Eyes

You have a lot of latitude when you're drawing eyes because the curves and angles of the lids vary widely from individual to individual. If you're drawing a portrait of someone, getting these angles right is essential to capturing their likeness. Some people have thick eyelids. Some people have lids that droop or fold over. Others may have bags under their eyes. The size and value of people's irises vary, and the dark pupil in the middle of the eye changes with the light and emotion of the person. As you render these variations you must also consider how the ball of the eye sits inside the bony skull and is covered by skin.

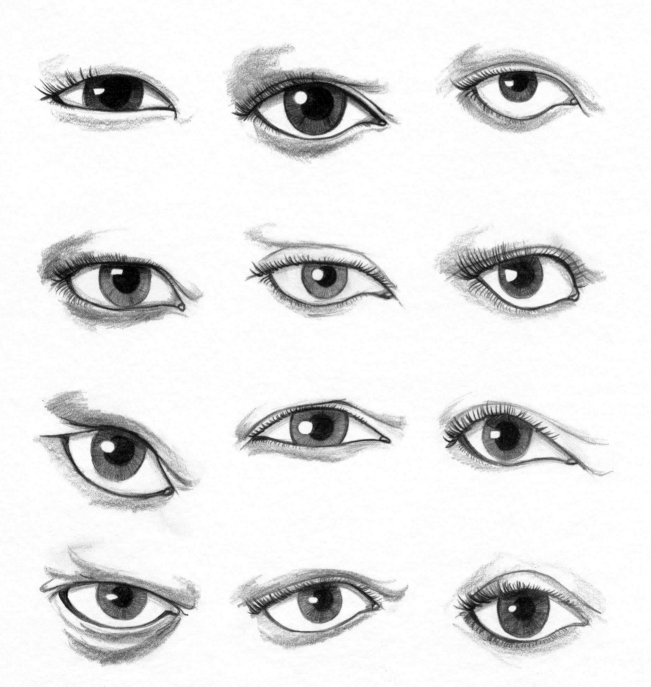

The nose is such a large feature on the face, but people often just draw the contour of its shape and then put two black dots below for the nostrils. You have to think about the structure of the nose and the way it sticks out from the face if you want to draw it convincingly.

As with everything else, you can break down the nose into simple shapes. If you start with a box to define the length of the nose you can quickly capture the space and angle at which the nose sits in relation to the face. Next, you can add some bell-like shapes along each side for the nostril areas. Once you start working with these basic building blocks you can more easily alter them to shape the nose and give it character.

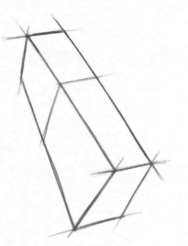

1 Draw a Box
The nose sticks out from the face. Draw an angled box shape to act as a foundation for the nose.

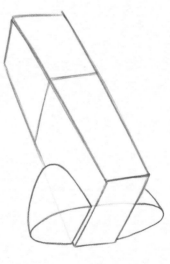

2 Add Nostril Shapes
Add a small bell shape on each side of the box for the nostril area.

3 Taper the End and Add Nostril Holes
The upper half of the nose has a bony structure below but the lower half is built from cartilage. In these drawings, the horizontal line about halfway down marks the edge of the bone. Below that, the tapering shapes represent the cartilage portion. The end of the nose rounds off and turns back to form the bottom of the nose. The bottom of the bell shape has an opening. Make sure that when you draw the opening for the nostrils you give the bottom ridge some width.

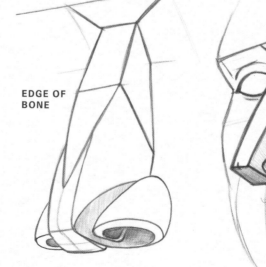

EDGE OF BONE

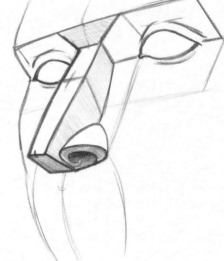

4 Draw a Variety of Noses

Play around with different angles and proportions of the different segments of the nose. Like the eyes, the nose also varies enormously from person to person. The overall size in relation to the face, whether it's turned up or hooked down at the bottom and how prominent the bridge of the nose all dramatically impact the look of the face.

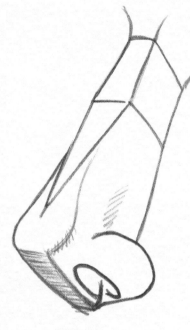
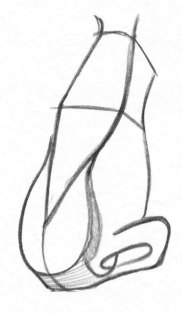
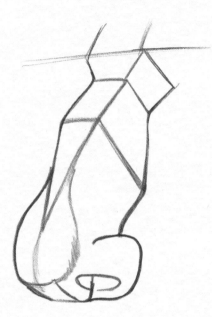
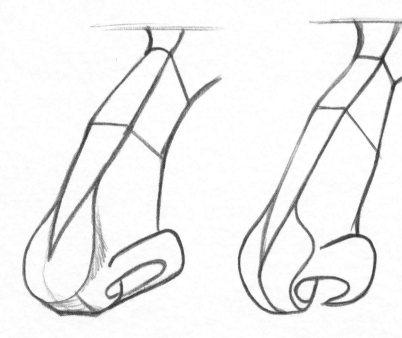
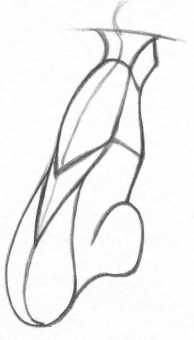

MOUTH

The mouth doesn't have as much volume as the nose, but it's important to think of its dimensional qualities when you draw it. Because of the teeth and muscles, the mouth area forms a saucer shape. It's round and thickens in the middle. Don't draw the lips as mere lines. Instead, carve the lips out of the disc shape. When you think about the mouth three-dimensionally, it makes it easier to draw at different angles and to stretch and compress the shapes to change the expression.

1 Draw a Disc
To draw a mouth, you don't just draw the lips; you need to consider the whole mouth area. The disc-like shape of the mouth area is created both by the muscles of the mouth and the teeth and bones they rest on.

2 Draw Lips
The lips are then carved into the disc shape. The top lip faces downward and the bottom lip faces more upward. Some lips are very full and some are much more slim. The shape and size varies greatly.

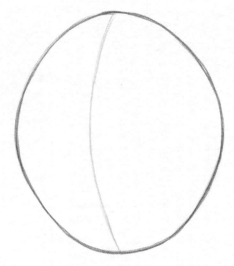

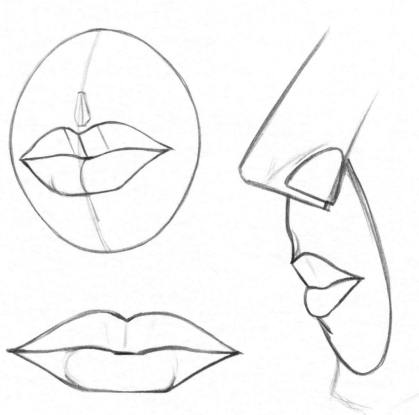

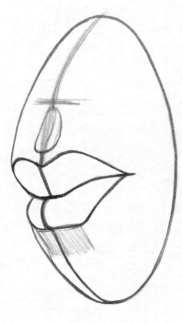

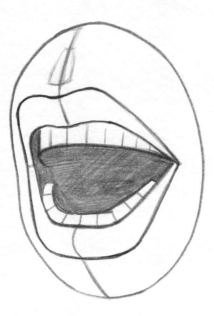

3 Draw an Open Mouth

When the mouth is open, the lips spread apart and reveal the teeth. Start your drawing by elongating the disc shape. Then add the upper and lower lips.

4 Draw Mouth Expressions

The whole mouth area stretches and compresses as the persons makes expressions or speaks. Practice by making different expressions in front of a mirror. Notice how the whole mouth area moves as you pucker, smile, grimace and smirk. Sketch a few different mouth expressions.

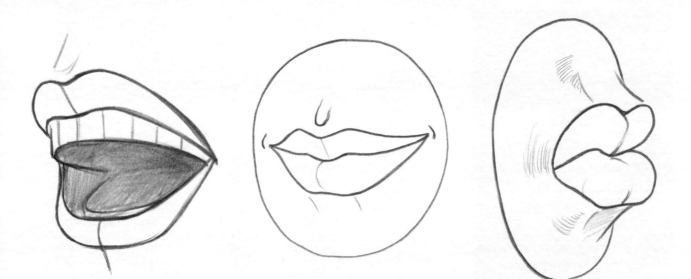

When the mouth is smiling, the lips stretch and thin. When the mouth is puckered, they squash together and push out. The three-dimensional forms of the mouth are transformed using the same principles used to manipulate simple boxes, spheres and cylinders.

The ear has a complex shape that is sometimes hard to visualize. It's easier to break it down into three major parts: the outer edge (consisting of the helix at the top and the lobe at the bottom), the inside form (called the antihelix), and the rounded wedge that connects the ear to the head.

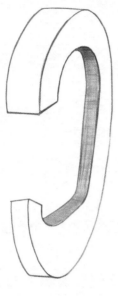

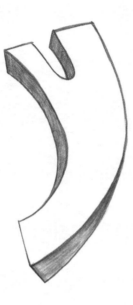

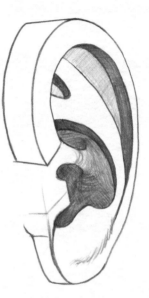

1 Draw the Outer Edge
Draw the outside shape of the ear as a simplified three-dimensional C-shape.

2 Draw the Inside Shape
Draw the inside of the ear as a simplified bent Y-shape.

3 Merge the Shapes
Merge the two forms to make a simplified ear. You can then add in the other anatomical parts like the earlobe and the flap in front of the ear.

The shapes and ridges of the ear are all designed to redirect sound into the ear canal. Look at the folds and imagine how sound waves would bounce off the outer ear and be channeled into the inner ear. Envisioning the function of anatomical parts can remind you of its form.

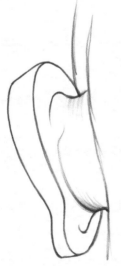

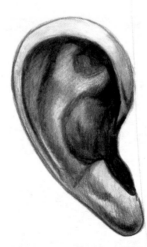

4 Draw the Back of the Ear
The back of the ear is pushed out by a cylindrical form cut into a wedge shape.

You can see how similar this more anatomically accurate ear is to the basic shapes version above. The rigid angles have become smooth undulations.

Expressions

All the features of the face move around for practical reasons (talking, eating, blinking, sniffing) and for emotive reasons. Expressions can stretch, compress or twist the features. This gives the artist an opportunity to play and exaggerate the face as a means of getting the emotion of the expression across. Watch yourself make different expressions in a mirror and notice how each of your features transform and move. This is why you can't learn to draw eyes or a nose by copying a picture; you must understand how the parts fit together and how they move. This understanding is what allows you to construct a head from simple building blocks and get it to express the emotion you want to portray.

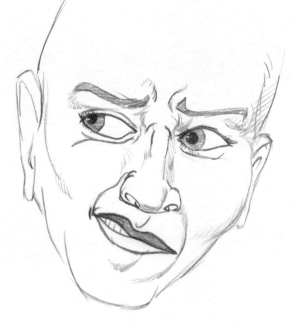

This model seems to be looking at something unpleasant. The twisted mouth and flared nose hints at repulsion. The furrowed brows express worry. The sideways glance shows he may not want to face the source of his concern directly. The twisting and compressing of the features express his emotions.

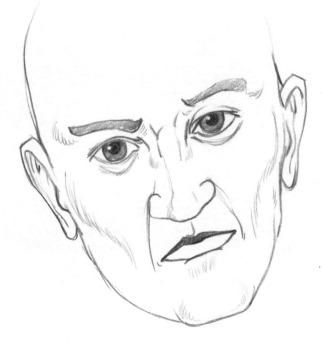

This neutral expression is subtle, but the lines beside his mouth and the bags under his eyes express weariness. His gaze engages the viewer directly rather than making us figure out what he's reacting to. Small changes to the face would make a dramatic difference to the way we react to his expression. Downcast eyes will make him seem sad. A lifted eyebrow may will him appear skeptical.

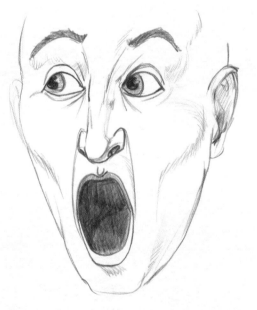

The look of surprise stretches all the features vertically. The eyebrows are raised. The eyes are wide open. The wide-open mouth stretches the nose and elongates the whole face.

Neck

In previous chapters, you used a simple curved cylinder to represent the neck. Anatomically the neck is held up by the trapezius muscle in the back that stretches from the base of the skull, down the neck and out to the shoulders.

The sides have long muscles (called the sternocleidomastoid) that connect to the skull behind the ear to both the clavicle and sternum. This is what turns the head from side to side.

Below the chin, a series of muscles pull back toward the neck (connecting to a bone called the hyoid). On lean people,

this will be a fairly flat plane. On heavier or older people, this area can bulge out into a "second chin."

The front of the neck also has several muscles, but in general, the shape is determined by the throat, which includes the windpipe (trachea), Adam's apple (larynx) and glands.

When drawing this area, start with a central cylinder and attach the muscles to that. Connect the chin to the throat, the back of the skull to the shoulders and the side of the skull to the clavicle. All of these muscle shapes will stretch and compress as the head moves in relation to the torso.

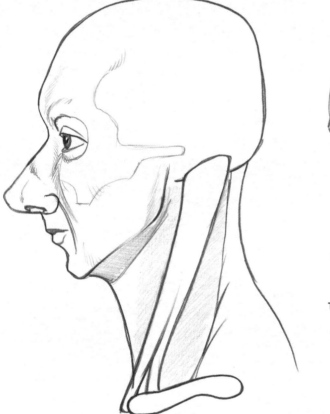
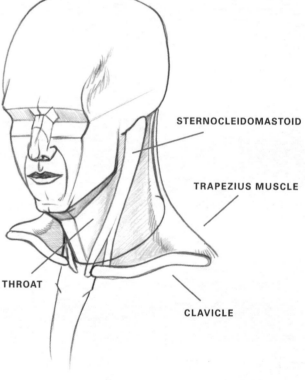

STERNOCLEIDOMASTOID

TRAPEZIUS MUSCLE

THROAT

CLAVICLE

In the drawing on the right, you can see the bottom part of the cylinder used to build the simplified neck. The muscles then are built around that round shape. The sternocleidomastoid muscle wraps around from the base of the skull to the clavicle and breastbone. The throat moves down the centerline at the front of the neck. The trapezius muscle attaches to the back of the skull and spreads down from the outer third of the clavicle, out to the shoulder and down the back.

Once all of the parts of the head and neck are covered by skin and fat, they become far less distinctive. The muscles still affect the surface topography of the body, so you have understand the shapes of the muscles that lie below the skin. Knowing where the muscles are and their three-dimensional qualities will help you know what to look for when you're studying a live person.

MOVEMENT OF THE WAIST

The spine is the only thing that connects the skeleton of the upper and lower body. The rest of the structure that holds the body upright is made of muscle. The muscles in the front, back and sides all work together to brace the body when standing tall or to twist and bend the waist when the body is in motion. You have to think of the muscles of the waist both as individual muscles and as a single unit. When one side contracts, the opposite side stretches. When the waist twists, all the muscles spiral.

When you're building your drawing, first determine what the motion of the waist is (i.e., through the armature or gesture), and then construct the individual muscles to reflect the twist or bend you indicated.

Abdominals

The abdominal muscles connect the rib cage to the pelvis at the front of the torso and bend the waist forward when they contract. The muscle is made up of eight muscular parts separated by connective tissue. These divisions are what give lean, muscular people the "six-pack" abs.

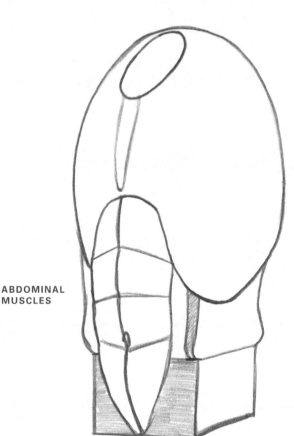

ABDOMINAL
MUSCLES

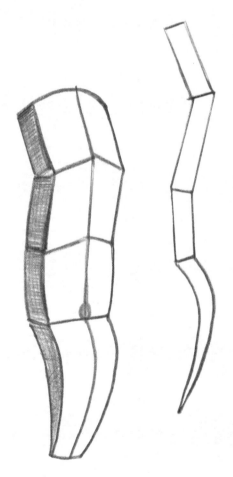

The fibrous connections between each of the ab muscles arch upward as they near to the rib cage and are flat or arch downward toward the hips. The belly button sits along the middle line between the left and right abdominals often nearest the bottom-most quadrant, but it can be higher or lower on each individual.

Generally, when the muscle is tightened, the top abs push out a bit at the rib cage. The next section moves back in. The third section is more vertical. The lowest section bulges out a bit before connecting to the bottom of the pelvis at the pubic bone. Obviously this area varies greatly, not only because of different fitness levels and fat content, but also depending on the pose and how a person is breathing.

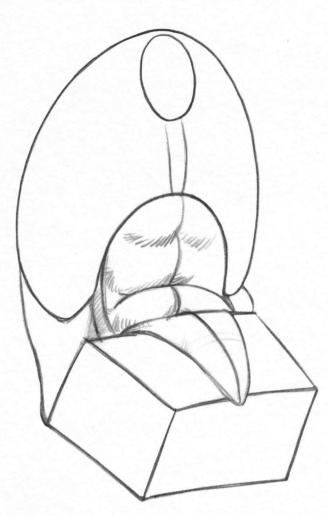

When the abdominals contract, they bend the torso forward, which causes the skin to pile up into rolls. This gives you an opportunity to give your drawing some depth by showing forms overlapping. Each time you put one shape in front of another you give your drawing a stronger sense of depth. If you only define the outside shapes of the forms, your drawing will look flat.

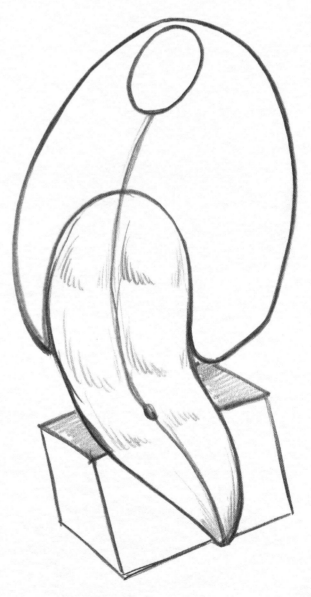

When the torso twists or the person leans back, the abdominals will stretch and flatten out the stomach area. You practiced twisting and bending the torso in the Chest to Hips demonstration (pages 42–43). This is the same concept, only now you are drawing just the abs instead of a general connection between the two masses.

To draw any muscle, you need to know where it connects to the bone at each end, the three-dimensional shape of the muscle and what joint it is moving when it contracts. For the abdominals, once you've drawn in the chest and pelvis shapes, you can easily connect the arch of the rib cage to the hips with this sheet of muscle.

External Obliques

At each side of the waist are muscles that bend the torso left and right and help to twist the torso. The muscles connect from the side of the rib cage to the top of the pelvic bone. This area also stores a lot of fat that can cause the flesh to pile up on the side of the body that is compressed.

Think of the oblique muscles as a thin, soft box that is connected to the rib cage at one end and the pelvis at the other.

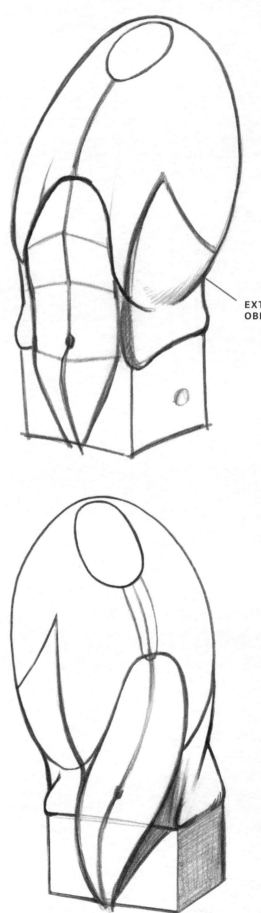

EXTERNAL OBLIQUES

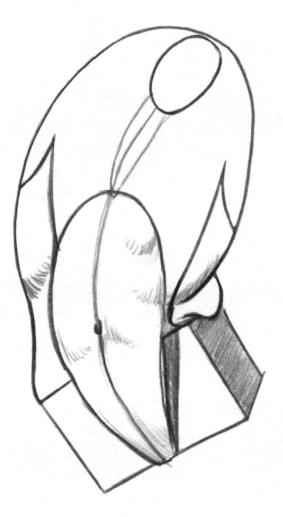

In these drawings you can see the effect bending and twisting has on the external obliques. In the first drawing the torso stands tall and the obliques follow the contour of the rib cage, filling out the space between the rib cage and the pelvis. In the second drawing the skin over the obliques bunches up on one side and stretches on the other as the torso bends to the side. In the third drawing, the torso twists, causing the obliques to stretch and rotate around the midsection.

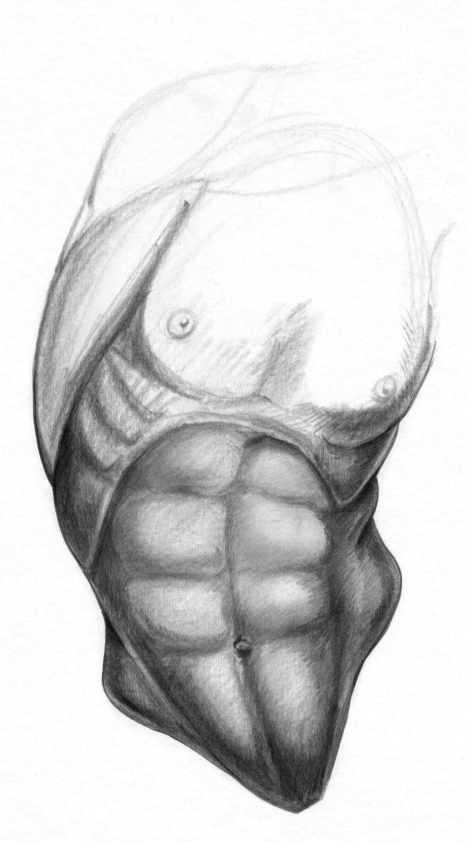

This model is very lean, so you can see the breaks in the abdominals more clearly than you would on most people. The slight twist of the body is causing the muscles to stretch. The model's raised left hip causes the flesh at the side of the body to pile up a bit under the ribs. If the figure had more fat or wasn't as muscular, these effects of stretching and compression would still affect the shapes in a more muted way.

Erector Spinae

The major group of muscles that moves the waist at the back of the body is the erector spinae, two long bundles of muscles that run along the sides of the spine and connect the rib cage to the back of the pelvis at the tailbone. These muscles are the counter to the abdominals. The abdominals contract to bend the torso forward; when the erector muscles contract, they arch the torso back.

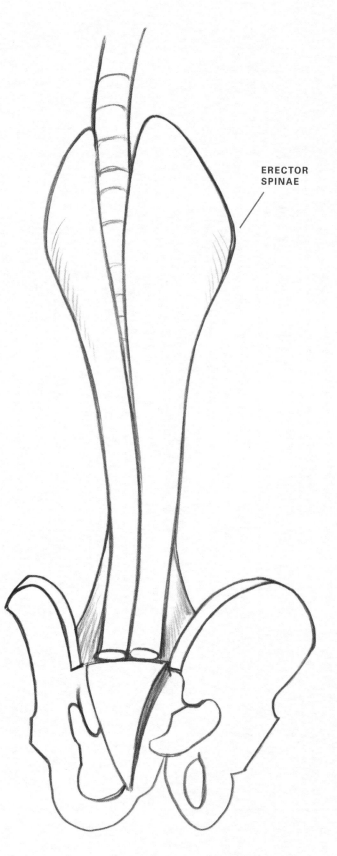

ERECTOR
SPINAE

This muscle group is cylindrical near the hips, and it fans out and flattens as it goes up to the rib cage.

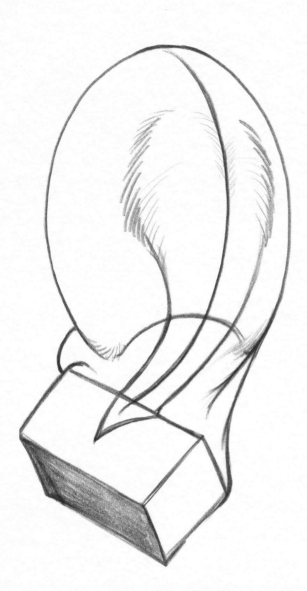

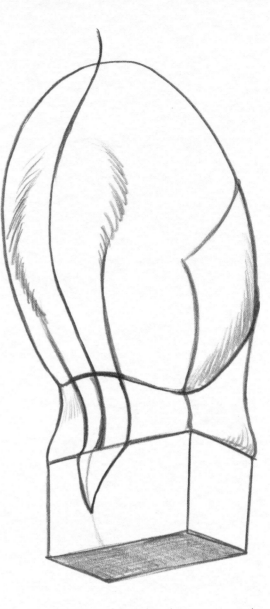

Structurally, the erector muscles are like thick cables along the small of the back and spread out to connect to different ribs as they go higher on the back. Although they are deeper in the body than other large back muscles, their volume can still easily be seen pushing out along the middle of the back.

Mirroring the movement of the spine, the erector muscles shift and twist along with the rest of the torso. When the torso is neutral, the muscles are straight along the center of the back. As the torso twists and bends (as on the left), the muscles twist and bend along with it.

EXERCISE

Start by drawing the simplified rib cage and pelvis from the Rib Cage and Spine demonstration (pages 24–25). Don't just draw it standing straight up; try it from different angles and different poses. Use a reference photo if you like or invent poses on your own. If you have colored pencils you can draw in a light color; if not, you can use tracing paper or a light table. Next, in a slightly darker color or on an overlay sheet, draw the simplified shapes of the torso from the Chest to Hips demonstration (pages 42–43). Emphasize the twist, stretch or compression of the waist. Finally, in a dark color or on a new sheet, draw in the abdominals, external obliques and the erector spinae. Really pay attention to their three-dimensional qualities and the way they change with the movement of the body.

MOVEMENT OF THE UPPER LEG

All of the muscles that move the upper leg originate from the pelvis. Some of those muscles attach to the upper leg bone and others cross both the hip joint and the knee, and attach to the lower leg.

The gluteal muscles of the butt cross the hip joint and largely work to straighten the hip when it's bent and to lift the leg behind you. The hamstrings attach to the hip below the gluteal muscles and connect to the lower leg. Because they cross two joints, they both pull the leg back and bend the knee. The quadriceps provide the opposite function of the hamstrings. They also connect from the hips to the lower leg and work to lift the leg and straighten the knee.

On the inside of the leg are the adductors that connect the hip to the upper leg bone and pull the leg in. Opposing them are the muscles that connect to the iliotibial tract (including the gluteus maximus and tensor fasciae latae), which connects the hip to the lower leg and moves the leg out to the side.

Knowing what function the muscle serves is useful because when you draw a body that's moving you'll know which muscles are flexing and pulling and which are soft and loose. A muscle that is working will be fuller and more visible than one that is relaxed.

Gluteus

You can see two main muscles of the butt at the surface: the gluteus maximus and gluteus medius. The maximus is the main large muscle that gives the back of the hips its shape. It connects all along the back of the pelvis near the tailbone to the upper part of the femur and to a long band (iliotibial tract) on the outside of the leg that connects below the knee at the tibia. The gluteus maximus is mainly used for straightening your leg at the hip.

The gluteus medius is a smaller muscle that connects all along the ridge of the pelvis bone and the top of the femur. This muscle lifts the leg to the side along with the tensor fasciae latae, which sits next to the gluteus medius, a little forward of it on the pelvis.

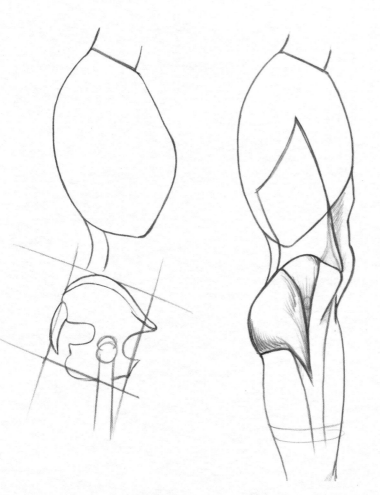

When standing, the hips are naturally tipped a bit forward. The gluteal muscles connect along the ridge of the pelvis and round out the shape of the bottom.

The gluteus maximus is the largest muscle of the butt. It connects to the back part of the pelvis and is fuller at the bottom. Part of it connects to the iliotibial tract at the side, but most of it connects to the femur.

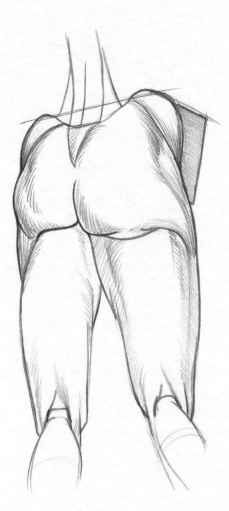

MEDIUS

MAXIMUS

The shape of the gluteus maximus is a bit like a kidney bean that's wider at the bottom than the top. Its shape is affected both by the bulk of the muscle and the shape of the pelvis to which it attaches.

The gluteus medius is more of a wedge shape that is wider at the top and tapered down toward the iliotibial tract.

Hamstrings

The hamstrings are a group of muscles that move the leg in a variety of ways. These muscles bend the leg at the knee, rotate the leg when the knee is bent and pull the whole leg back. To simplify this area, there are two masses that are larger at the top of the leg and reach down to connect to the lower leg on each side. The calf muscle fits in between them.

On the outside of the leg are the biceps femoris, vastus lateralis and vastus intermedius.

On the inside of the leg are the adductor magnus, semitendinosus and semimembranosus.

You can group these muscles into two large muscles that begin under the gluteal muscles and connect to the lower leg on each side of the calf. They are wide at the top and tapered down to the bottom.

HAMSTRINGS

To simplify this area you can think of the hamstrings as two muscle groups that start below the gluteal muscles of the butt and go down the length of the upper leg bone and attach to the lower leg below the knee. Their fullest point is about one-third of the way down. Think of them as a tapering cylinder with a bulge.

Quadriceps

The four large muscles of the quadriceps are what give the front of the leg its shape. These muscles work together to lift the leg and extend the lower leg at the knee. These muscles connect to the front of the pelvis, or upper part of the femur, and to the kneecap. The kneecap is then connected to the lower leg by a ligament. The quadriceps contract and pull on the patella (kneecap), which redirects the force across the bent knee to pull on the front of the tibia. You use these muscles when jumping or kicking.

The big quad muscle in the middle is the rectus femoris, and it is the one that connects to the pelvis.

The muscle to the outside of the leg is vastus lateralis, and it connects to top of the femur.

The muscle on the inside is the vastus medialis, and it connects near the top of the femur on the inside.

The vastus intermedius is the fourth quadriceps muscle, but since it is covered by the other three muscles, it typically cannot be seen.

Each of these muscles is a vaguely teardrop shaped. They start narrow at the top of the leg and then widen as they go down the leg, then taper again before connecting to the patella. A ligament connects the patella to the tibia.

Here you can see how the three visible muscles of the quadriceps fit together and where each muscle is wide or narrow.

The important thing when learning the muscles of the body from an artist's perspective is knowing the three-dimensional shapes of the muscles and how they all fit together. Notice where the muscle is fuller and where it narrows. Learn how the muscles sit next to each other in space. Also, watch how they shorten and thicken when they flex, and how they soften and stretch when they're not.

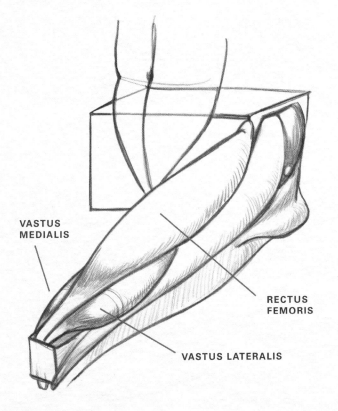

VASTUS MEDIALIS

RECTUS FEMORIS

VASTUS LATERALIS

Adductors and Sartorius

The adductors of the leg are a series of muscles that connect from the bottom of the pelvis to the leg bones and work together to pull the leg inward (e.g., when you squeeze your knees together). They connect at various points from the upper part of the femur down to the tibia.

These muscles aren't as thick at the quadriceps and are to the inside of the leg. They fill out the space between the pelvis and the quadriceps. As a group, the adductors are somewhat cone shaped with the peak of the cone near the pubic bone and the base spreading from the top of the leg to just below the knee.

The sartorius is a long, narrow muscle that visually divides the quadriceps and the adductors. This muscle connects to the pelvis just above the largest quadriceps muscle (rectus femoris) and curves down to connect to the tibia. The sartorius rotates the leg so the knee and foot can point out to the side.

On the outside of the sartorius is the quadriceps. On the inside are the adductors. The sartorius appears to be the dividing line because the adductors connect to the bone below the sartorius and quadriceps.

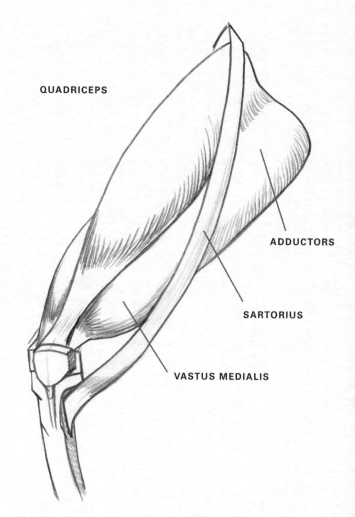

QUADRICEPS

ADDUCTORS

SARTORIUS

VASTUS MEDIALIS

The three main quadriceps muscles are to the left of the sartorius. The adductors are to the right and connect to the femur behind both the sartorius and vastus medialis.

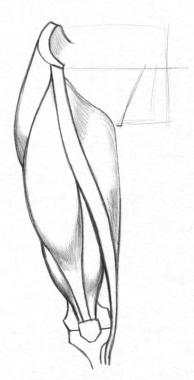

The adductors of the leg are a series of muscles, but you should treat them as a single form for the sake of simplicity. These muscles attach to the pelvis at the pubic bone and connect all along the femur down to the tibia.

Knee

The knee is a blocky shape because it is formed by the ends of two wide bones. The end of the femur and top of the tibia both flare out at the knee to accommodate several muscles that connect in this area.

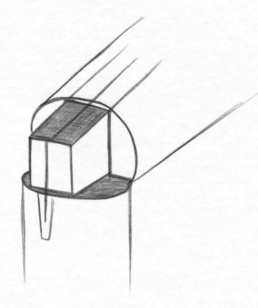

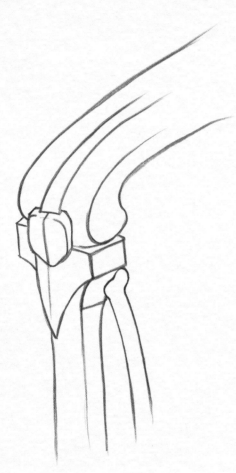

The simplified form of the leg uses a box shape for the knee not only because it clearly shows the angle of the bend but also because the actual structure of the knee has a squarish appearance.

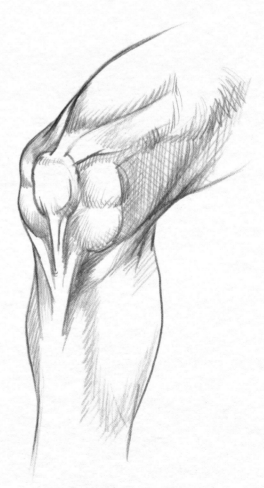

The bones of the knee are what give it its blocky shape. The two heads of the femur form the top of the knee. The tibia also widens out at the knee to square off the bottom of the knee. The patella sits in front of the joint. The tibia protrudes a little lower than the patella. This area is called the kneeling point.

The front of the knee doesn't have any muscle, only bone and ligaments. The quadriceps connect to the patella, and a ligament connects the patella to the kneeling point. The dominant shapes you see when the knee is bent are the heads of the femur and tibia, the patella in the center, the muscles above the knee and the ligament below.

77

Kneecap

The kneecap is a bone that floats in front of this hinge and acts as a lever to aid the quadriceps in extending the lower leg.

EXERCISE

Find artwork that you like of a realistic figure drawing or painting that includes the leg. Now reverse engineer the anatomy of the leg in that pose by drawing the anatomical forms. Notice how the artist handled simplifying or emphasizing the anatomy in their work. Michelangelo's Renaissance drawings express the anatomy differently than the Art Nouveau style of Alphonse Mucha. And both depict it differently than contemporary fine or commercial artists of today.

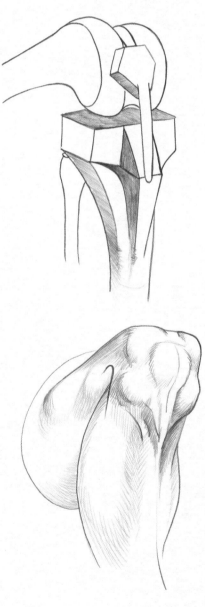

The patella sits in front of the femur and tibia. When the leg bends, it doesn't rotate up with the bone but stays in place to both protect the joint and give the quadriceps better leverage to extend the lower leg.

In the two drawings above you can see how the structure of the bones impacts the look of the knee as you'd see it on a person. The kneecap floats in front of the upper and lower leg bones.

MOVEMENT OF THE FOOT

The muscles in the lower leg make the foot move. The largest muscles on the back of the leg are the ones that extend the foot; we use them when walking, jumping or standing. These muscles bulge about one-third of the way down the leg and narrow as they go down the leg and attach to the heel. The front of the leg has smaller, cordlike muscles that lift the foot. From the front, the leg appears to have a slight inward curve.

Calf

The calf has two main muscles called gastrocnemius. Both of them connect the back of the femur to the heel of the foot via the Achilles tendon. The two muscles are near mirrors of each other. They bulge out on the top half of the leg where they connect to the Achilles tendon. The calf muscle on the outside of the leg bulges out a bit higher than on the inside muscle, giving the leg its visual rhythm.

Since the muscles in the front of the lower leg are long and slender and the calves are wide, the calves are very visible from the front.

HAMSTRINGS

GASTROCNEMIUS

ACHILLES TENDON

SOLEUS

Notice the gentle curve of the leg with the muscles in place. The muscles are long and sweeping on the outside of the leg. Also notice the widest point of the muscles is higher on the outside of the leg and lower on the inside. The bones at the ankle are just the opposite: higher on the inside and lower on the outside.

One more muscle of the calf, called the soleus, appears on the lower half of the lower leg. It is mainly covered by the two large calf muscles mentioned above, but you can see it on each side of the Achilles tendon. The soleus also works to extend the foot.

Foot and Toes

When you began drawing the foot as part of the Level 2 Lower Body demonstration (page 29), you used a simple wedge and box shape. In the Level 3 Lower Body demonstration (pages 47), you shaped the wedge to look a bit like a shoe. If you soften this form further, you get something more like an actual foot.

Like hands, feet vary greatly between individuals. Some people's feet are rather straight, while others curve. Some are more or less flat, while others have a tall arch. Some people have long skinny toes, while others have wide short toes. As always, when you're drawing an individual, take note of their unique shapes and adapt your drawing to match.

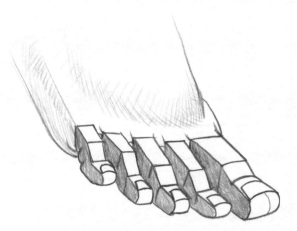

When drawing toes, it's easiest to break them down into boxes so you can clearly define the top and sides. Generally the toes are like a staircase, with the first and third segments more flat and the middle section angling down.

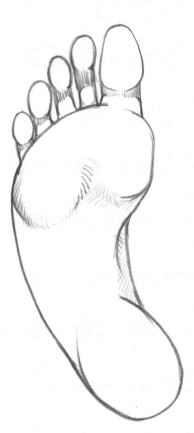

The toes aren't really boxy, though. They have a rounded bone at the top and a fat pad below for cushioning. This gives the toe a more cylindrical form that is narrower at the top and wider at the bottom.

The bottom of the foot has the large round pad for the heel and a wide kidney bean–shaped pad at the front of the foot.

The heel of the foot can be drawn as a box with soft edges. This helps to define the back of the foot, where the heel connects to the Achilles tendon, the bottom pad under the heel and the sides where it meets the top arch.

On this three-quarter back view of the leg, you can see how the skin obscures and blends the muscles together into larger shapes and forms. Each muscle contributes to the overall shape but none of them draw attention away from the appearance of the leg as a whole. For example, on the lower leg you can see the bulging calf muscles as they connect to the long Achilles tendon. That form sits above the soleus muscle, which in turn sits above the fibula bone, which is in front of the small muscles at the front of the lower leg. Each muscle is important, but one needs to flow into the next to keep the viewer's eye moving through the drawing rather than stopping at each part.

When you draw any part of the body, you don't just draw the outside shape that you see and then fill in the inside with muscle shapes. You have to build up the drawing from simple forms molded into anatomical forms. The contours and shading of the body is a by-product of knowing how to draw the muscles in three dimensions.

EXERCISE

Take a drawing you created of the anatomy of the leg. Now redraw that pose as you would see it with skin. Keep thinking about the three-dimensional shapes of each muscle, but instead of delineating each shape, let those underlying forms influence the rise and fall of the surface of the body.

MOVEMENT OF THE ARM AT THE SHOULDER

The shoulder is a complicated area because there are so many muscles that give the arm its range of motion. The shoulder muscles, the chest muscles and many of the muscles in the upper back are all there to move the arms. The deltoid muscles lift the arm to the front, side and behind. The chest muscles provide the power to lift the arm in front of you. The muscles of the back provide the power to pull your arm from an extended position back to your side and a bit behind you. The muscles connected to the scapula help you lift and lower your shoulder and rotate your arm in and out.

Pectoralis

The pectoralis muscles are the large muscles of the chest that lift the arm in front of the body. It connects along the clavicle, the breastbone and along the ribs above the arch of the rib cage.

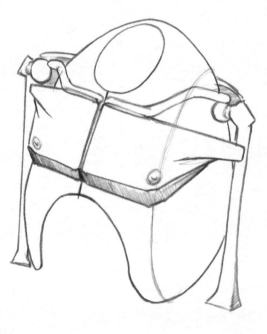

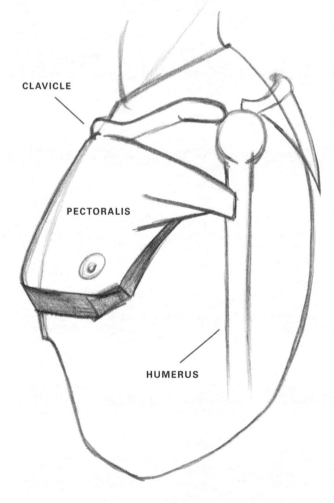

CLAVICLE

PECTORALIS

HUMERUS

Remember, you're drawing the muscles in three-dimensional form, so be sure to give it thickness so it stands out from the rib cage.

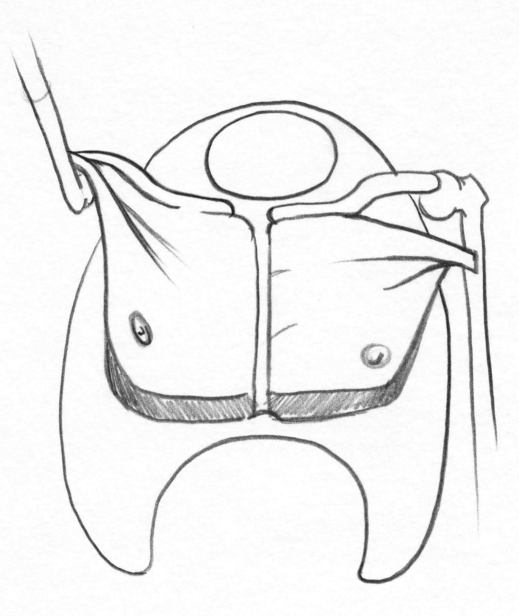

The pectoralis muscle twists as it connects to the humerus bone so that as a person raises his arm, the muscle unravels. You can see on this body's left arm that the top part of the pectoralis is over the middle and bottom sections of muscle. When the arm is lifted, the bottom portion of the muscle is now no longer tucked under. This affects the way you draw the chest, because when the arm is at the side you can sometimes see how the muscle is layered.

Breast

A woman's breast sits on top of the pectoralis muscle. Each breast is not a round bubble but an object of mass and weight that is pulled by gravity. Since the rib cage is round, the breasts rest downward and to the side a bit. Just like all other anatomy, this varies from person to person.

Think of the breast as a water balloon suspended from above and resting on an angled surface.

The nipples on both men and women are round but will stretch into ovals depending on how the skin is stretched and the angle at which you're looking at the model.

Latissimus Dorsi

The big muscle of the lower back is the latissimus dorsi. It stretches from the back of the pelvis and tailbone and up the ribs along the spine, and it connects the arm and the back. It is the main muscle that pulls the arm down when you do a pull-up. It's also the muscle that makes up the back wall of the armpit.

This muscle is thicker as it comes together at the arm and spreads out into a triangular shape as it connects along the spine and pelvis.

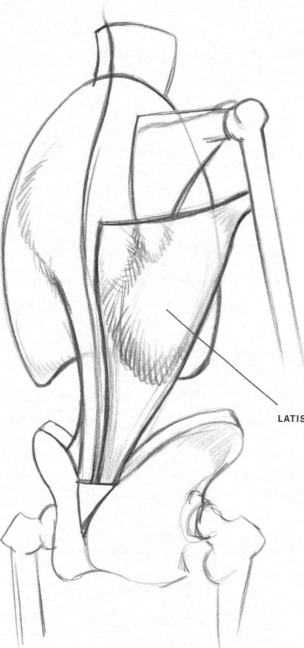

LATISSIMUS DORSI

The latissimus dorsi is the widest muscle on the back and is what gives bodybuilders their distinctive V-shape. It connects to the upper arm and stretches around the rib cage to attach near the spine and along the pelvis. When it's relaxed, the shape of the rib cage, the bottom of the scapula and other deeper muscles (such as the erector spinae) can usually be seen below.

Trapezius

The trapezius is a big muscle on the upper back that moves the scapula and clavicle, which in turn moves the shoulders up, down and back.

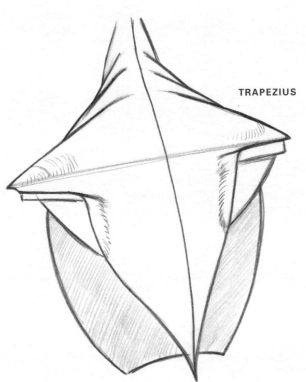

TRAPEZIUS

The lower portion of the trapezius connects the spine to the scapula. When this portion of the muscle retracts, it pulls the scapula closer to the spine and down. The trapezius muscles look like a diamond-shaped kite. It is the top layer of muscle and overlaps all the other back muscles.

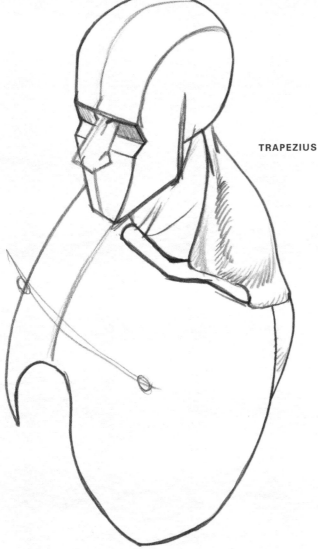

TRAPEZIUS

The upper part of the trapezius connects the neck to the outer third of the clavicle. This triangular portion of the muscle lifts the shoulders and is fairly thick.

Serratus, Rhomboid and Scapular Region

Several muscles attach to the scapula and work to move the
shoulder in various ways.

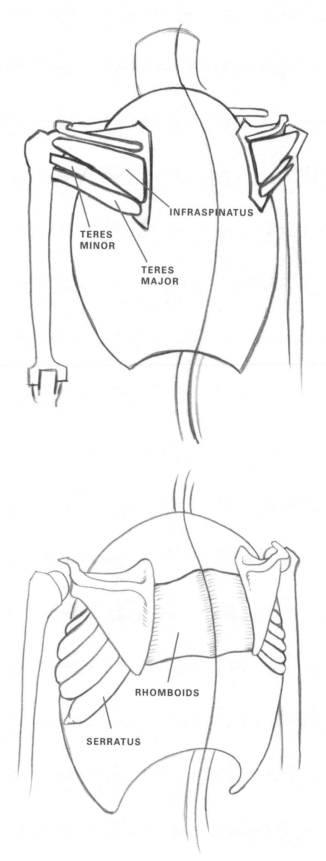

The three muscles on top of the scapula help move and
stabilize the shoulder. The infraspinatus and teres minor are
part of the rotator cuff and assist in rotating the arm at the
shoulder. They connect to the back of the humerus and aid
the latissimus in pulling the arm down. One leg of the tricep
muscle also connects to the scapula and it weaves between
the teres minor and teres major.

INFRASPINATUS

TERES
MINOR

TERES
MAJOR

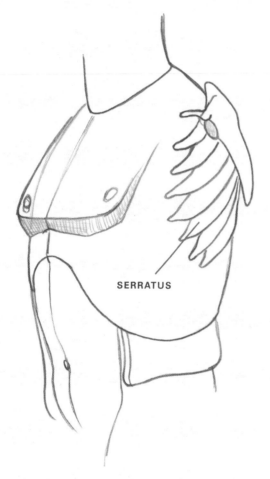

SERRATUS

RHOMBOIDS

SERRATUS

The serratus muscles connect to the bottom of the scapula
and reach down like fingers along the ribs. They are what
pull the scapula forward. They are completely covered by
the latissimus in the back, but they can be seen from the
front along the side.

The rhomboids work in conjunction with the trapezius to
pull the scapula toward the spine. They add bulk to the
middle of the back when they're flexed.

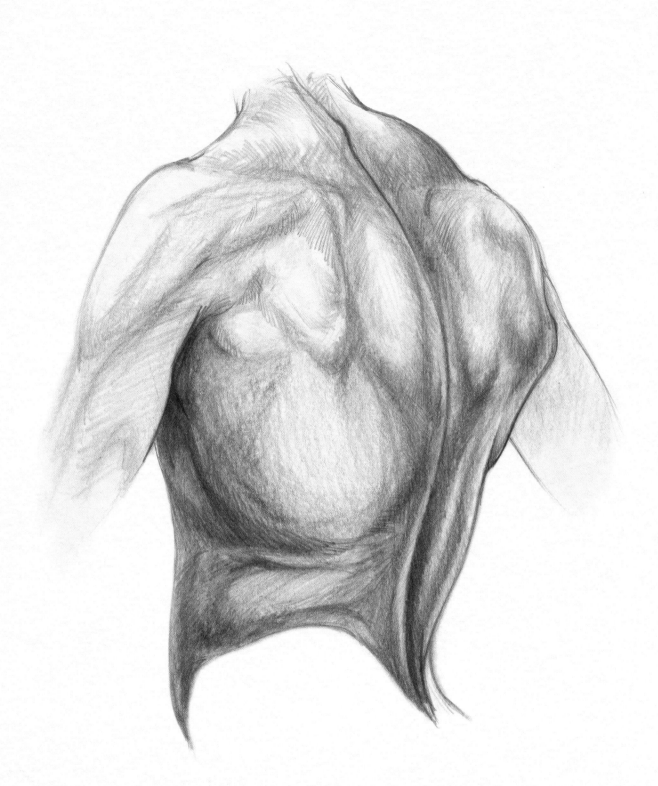

Many of the muscles in the back are there to move the arm. That means that most of the muscles connect to the humerus bone or the scapula. The largest muscles are the latissimus and the trapezius, so those two muscles, along with the scapula, will have the largest influence on the shape and contours of the back. Once those are defined, you can add other muscles that are visible or simply add bulk to the back.

Deltoid

A lot of different muscles move the arm at the shoulder, but the one most people think of when you talk about shoulder muscles is the deltoid. This muscle is divided into three parts and is responsible for lifting the arm to the front, side and back. In the Arms and Hands demonstration (pages 48–51), you drew the deltoid as a wedge wrapped around a cylindrical arm. The deltoid connects along the clavicle in front and to the ridge of the scapula on the side and back. This muscle connects to the outside of the arm about halfway down the humerus.

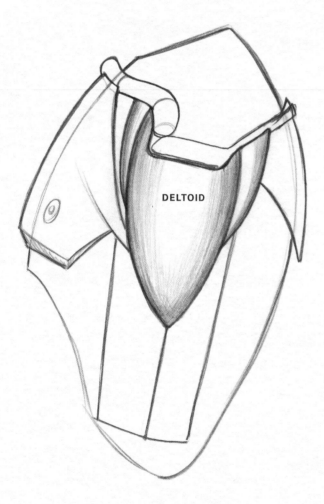

DELTOID

The deltoid is somewhat of a teardrop shape with the largest bulk at the top.

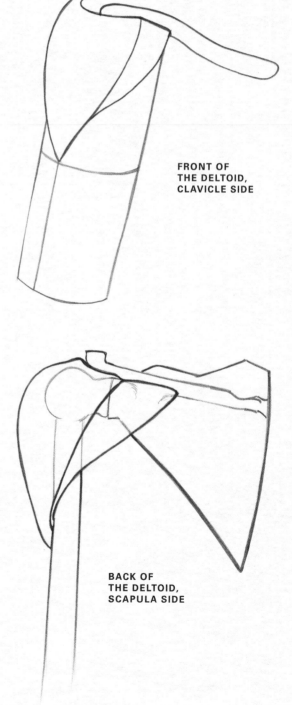

FRONT OF THE DELTOID, CLAVICLE SIDE

BACK OF THE DELTOID, SCAPULA SIDE

Muscle Overlap

It's helpful to know how the shoulder muscles fit together so you can overlap the forms in your drawing. Here is how the muscles are ordered.

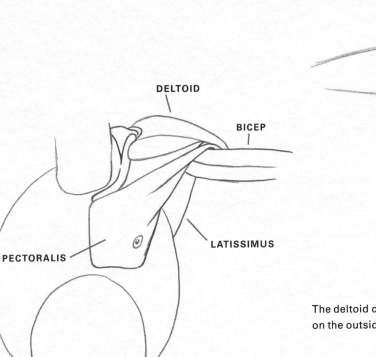

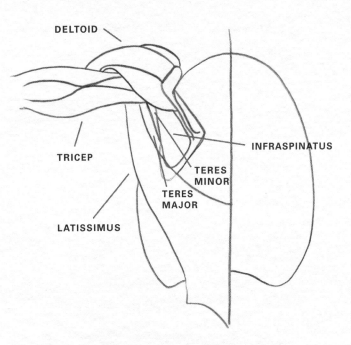

The deltoid connects to the arm between biceps and triceps on the outside of the arm.

The pectoralis connects to the arm under the deltoid and overlaps the biceps.

The latissimus connects to the arm between biceps and triceps on the inside of the arm.

EXERCISE

Search for photos of athletes that show the shoulder (gymnasts on the rings or Olympic divers in action are a couple of good choices) and print them out. With tracing paper, figure out the shapes of the muscles. Pay particular attention to how the muscles overlap each other. Remember, you're not just drawing lines but three-dimensional shapes.

The triceps overlaps the latissimus and teres major but is under the infraspinatus and teres minor.

MOVEMENT OF THE ARM AT THE ELBOW

The elbow pivots back and forth using the muscles of
the upper arm. The biceps bend the arm and the triceps
straighten it.

Biceps

The main muscles that bend the arm at the elbow are the
biceps. These two muscles make up the bulk of the front of
the arm. Together, their shape is a long cylinder that bulges
in the middle.

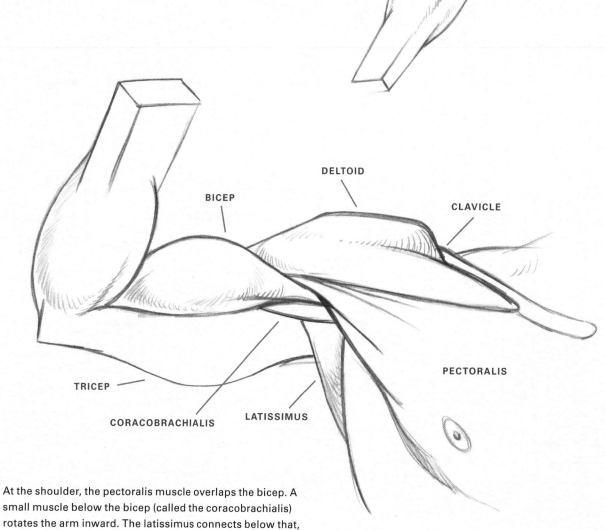

BICEP

DELTOID

CLAVICLE

BICEP

PECTORALIS

TRICEP

CORACOBRACHIALIS

LATISSIMUS

At the shoulder, the pectoralis muscle overlaps the bicep. A
small muscle below the bicep (called the coracobrachialis)
rotates the arm inward. The latissimus connects below that,
followed by the triceps.

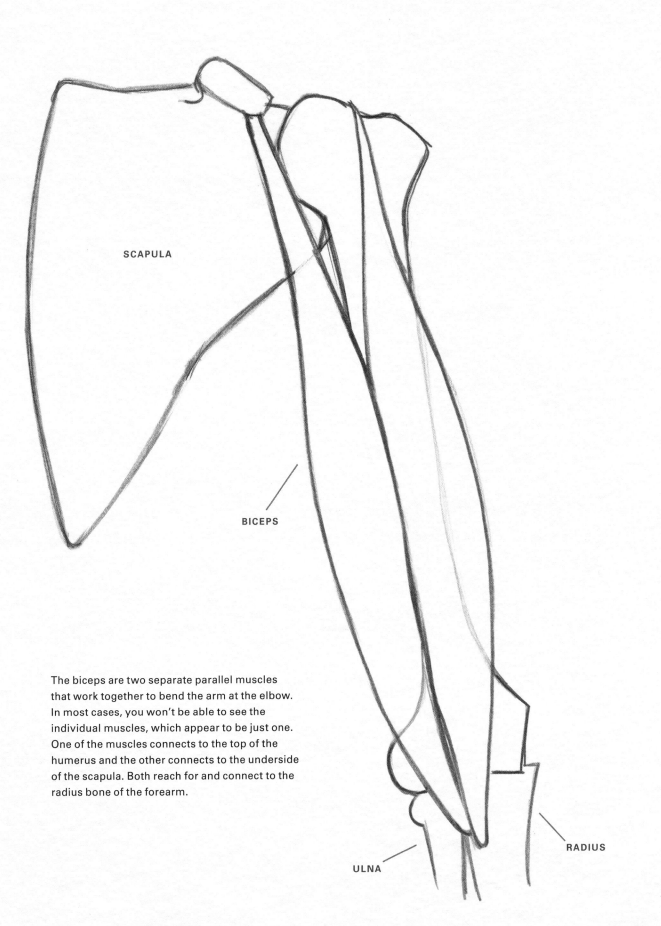

SCAPULA

BICEPS

The biceps are two separate parallel muscles that work together to bend the arm at the elbow. In most cases, you won't be able to see the individual muscles, which appear to be just one. One of the muscles connects to the top of the humerus and the other connects to the underside of the scapula. Both reach for and connect to the radius bone of the forearm.

ULNA

RADIUS

Triceps

The triceps are the major muscles on the back of the arm
that extend the arm at the elbow. When flexed, the muscles
together look a bit like a horseshoe that bulges in the middle.
At the top of the arm they are covered by the deltoid muscle
and connect to the elbow at the bottom.

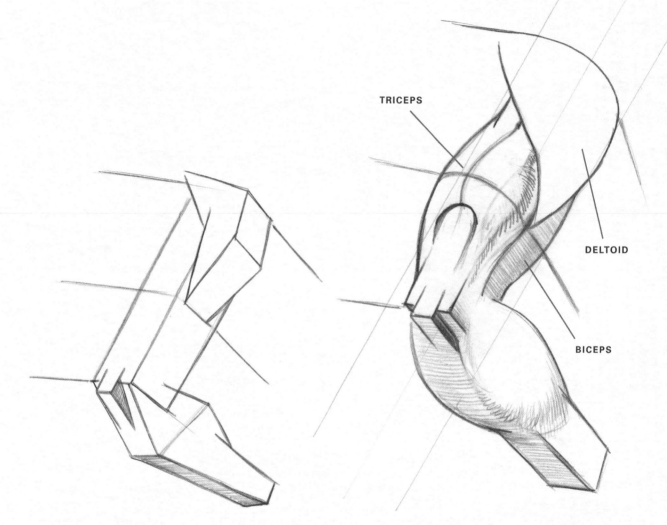

TRICEPS

DELTOID

BICEPS

There are many ways to simplify the anatomical forms. On the left, the arm is
built from blocky shapes. On the right, the same pose has more anatomical
forms. The long box of the upper arm is replaced by the bulging horseshoe shape
of the triceps and the cylindrical form of the biceps on the far side. The blocks
help to clarify how the arm sits in space, and the more rounded forms that more
closely reflect the anatomy retain the dimension established with the cubes.

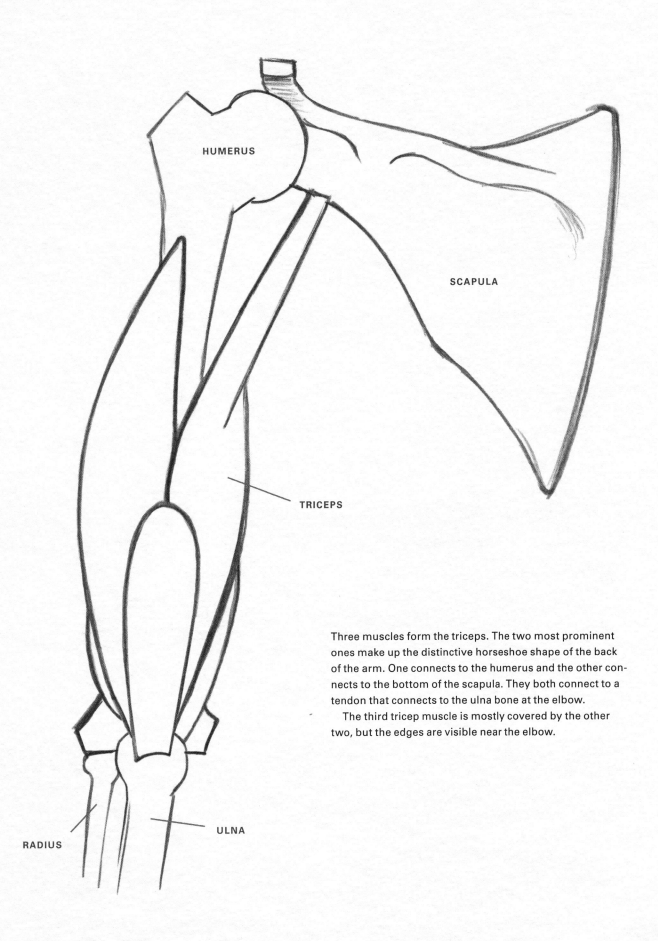

HUMERUS

SCAPULA

TRICEPS

Three muscles form the triceps. The two most prominent ones make up the distinctive horseshoe shape of the back of the arm. One connects to the humerus and the other connects to the bottom of the scapula. They both connect to a tendon that connects to the ulna bone at the elbow.

The third tricep muscle is mostly covered by the other two, but the edges are visible near the elbow.

RADIUS

ULNA

Elbow

The elbow gets its shape from the bones that come together to create the hinge. The big center knob is the end of the ulna bone of the lower arm. On each side of the ulna are the two lower heads of the humerus bone.

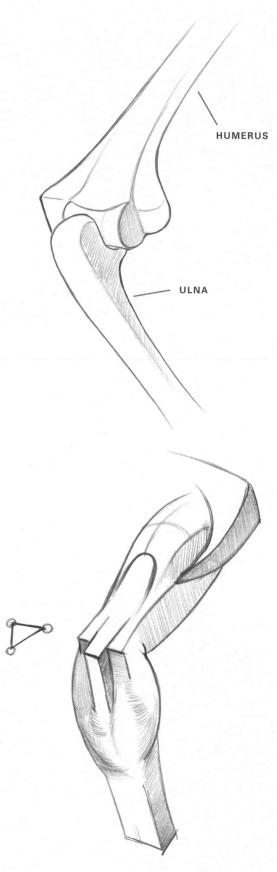

HUMERUS

ULNA

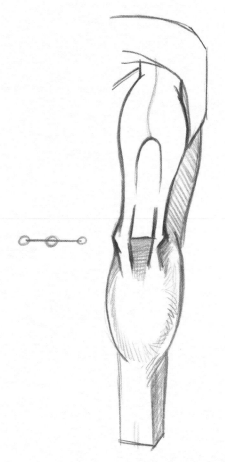

It's easiest to base the elbow off two overlapping cubes like you did in the Arms and Hands demonstration (pages 48–51). When the arm bends at the elbow, the ends of the bones slide around each other. If the arm is straight, then the three points of the elbow line up.

EXERCISE

Just as you did for the Kneecap exercise (page 78), find some life drawing examples that you like from artists throughout history and study how they handled this area. Re-create their drawings while focusing on capturing both the anatomy and three-dimensional qualities of the arm.

When the arm is bent, the ulna rotates downward and the three points form a triangle.

MOVEMENT OF THE ARM AT THE WRIST

The muscles of the forearm move the wrist and fingers, and rotate the forearm so the hand faces up or down. The basic shapes you've been using for the forearm are either a box or cylinder shape at the elbow and a box shape for the wrist. In between, the form bulges into a spherical shape.

It's easier to understand the muscles in the forearm if you break them down into their functions and treat them as one group of muscles that work together. Once you have a stronger grasp of how these muscle groups move, you can start to study the individual muscles in each group.

The hands don't have many muscles in them. The majority of muscles that move the fingers are in the forearm and connect to the fingers through string-like tendons. The muscle pulls the tendons and the fingers bend.

Forearm

One forearm muscle group, the flexors, curls the hand up at the wrist toward the forearm. The opposing group of muscles, the extensors, lifts the hand back at the wrist. The rotator group allows you to twist your wrist so that your palm faces up or down. Other muscles, such as the brachioradialis, are used to stabilize the forearm in a neutral position.

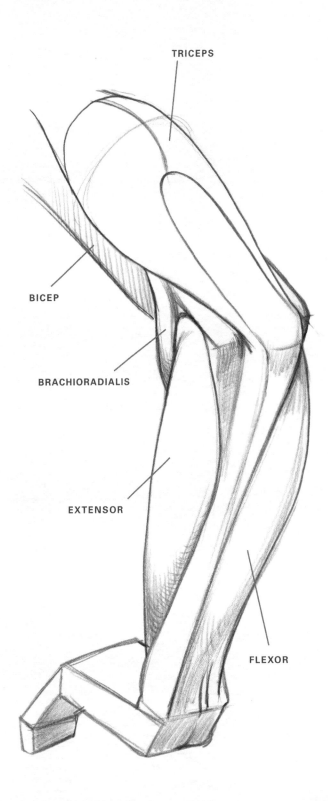

TRICEPS

BICEP

BRACHIORADIALIS

EXTENSOR

FLEXOR

Each muscle group of the forearm connects to one side of the elbow or the other. In the middle is where the biceps connect at the front or the triceps connect at the back.

The extensor group starts at the outside of the elbow and connects to the top of the hand.

The flexor group starts at the inside of the elbow and connects to the bottom of the hand.

The rotator group, which rotates the palm forward, starts near the flexor group on the elbow but connects to the radius bone about midway down.

The brachioradialis originates higher up the humerus than the rest of the extensor muscles and connects to the radius bone near the thumb.

HUMERUS

ULNA

INSIDE
OF ARM

RADIUS

OUTSIDE
OF ARM

LEFT ARM

FLEXOR

BRACHIORADIALIS

INSIDE
OF ARM

OUTSIDE
OF ARM

EXTENSOR

LEFT ARM

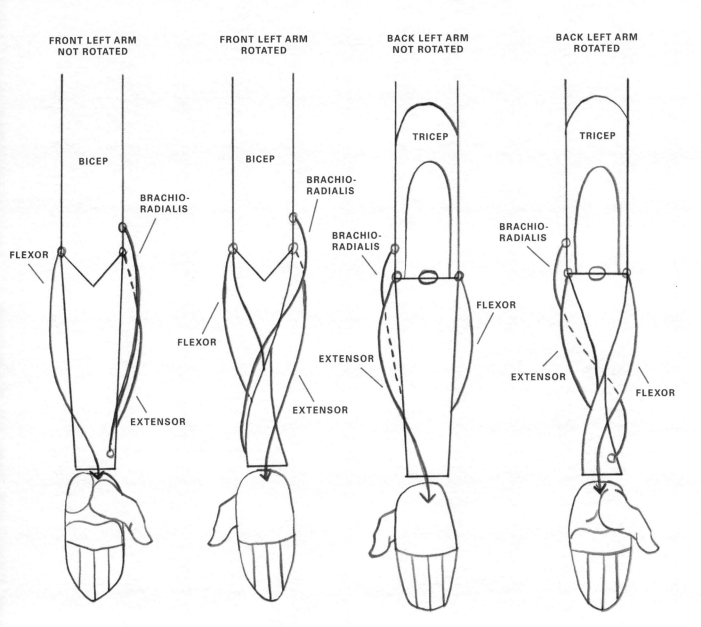

FRONT LEFT ARM NOT ROTATED

BICEP

BRACHIO-RADIALIS

FLEXOR

FLEXOR

EXTENSOR

FRONT LEFT ARM ROTATED

BICEP

BRACHIO-RADIALIS

FLEXOR

EXTENSOR

BACK LEFT ARM NOT ROTATED

TRICEP

BRACHIO-RADIALIS

FLEXOR

EXTENSOR

BACK LEFT ARM ROTATED

TRICEP

BRACHIO-RADIALIS

EXTENSOR

FLEXOR

Understanding how these muscles twist around each other as the wrist turns can be challenging. This diagram depicts how the muscles twist and overlap as the arm rotates.

EXERCISE

To help visualize how the muscles move when you twist your arm, put a piece of tape or draw a line on your left arm where the muscles stretch from your elbow to your wrist. Now when you rotate your wrist, you can better visualize how the muscles twist.

This arm is in a neutral position so the muscles of the forearm aren't twisted across the arm. The biggest muscle group on top of the forearm is the extensor group that pulls the hand back at the wrist.

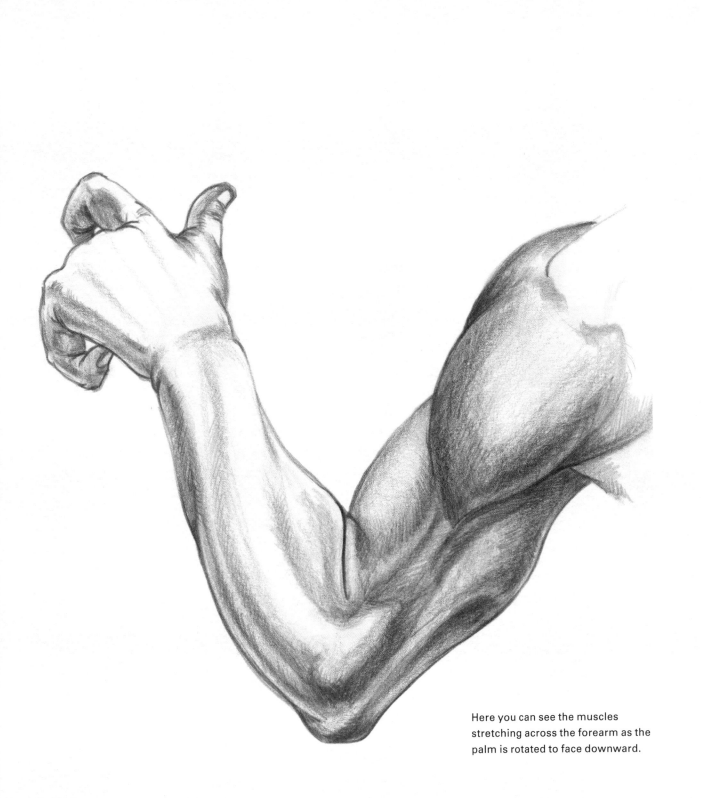

Here you can see the muscles stretching across the forearm as the palm is rotated to face downward.

Hand

In Level 3 (page 51) I broke down the hand into box forms, which clearly show how the hand is sitting in space. Once you've established the hand's three-dimensional form, you can start shaping it into a drawing that looks more like an actual hand.

The palm of the hand has three large masses: at the thumb, on the side of the hand and a kidney bean–shaped pad below the first knuckle of the fingers.

While proportions of the body vary from person to person, generally the middle finger is the longest. The ring and index fingers are shorter, and the pinky is the shortest. It you draw a line through all the knuckles of the fingers you'll see the arcs. This is helpful to determining the length of the fingers when the hand is spread out.

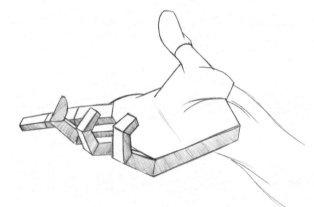

Here you can see the relationship between the hand constructed of boxes and one that is more anatomically correct. The boxes clearly define the hand in three dimensions. You can see the angles as the fingers bend. Once you've established the object in space—whether you do so by actually drawing the cubes or have a clear understanding in your mind—you can pay more attention to the anatomy.

Fingers

The bones of the finger run along the top of the finger. Below the bones are pillow-like pads. The knuckles on top of the finger gather skin into folds when the finger is extended. When the finger is bent the skin stretches taut at the knuckle and folds in on itself on the bottom of the finger.

The fingers don't have any muscles in them. Instead they have tendons that pull the knuckles. In the top drawing, you can see the tendon that extends the finger. It rests along the top of the bones, and you can sometimes see it under the skin of people's hands.

Below the finger are the pads of the fingers that cushion the joints and help with grip. The tendon that curls the hand is below the bone but can't be seen.

SKIN

Knowing the underlying anatomy of the body is so important when drawing the figure because the muscle and bone dictate what the surface of the skin looks like. What the skin rests on top of determines how you handle drawing the body. For example, understanding that the knuckle of the hand is bone and tendon means you draw the skin that covers it with a more solid feel than the softer, fleshy pads on the bottom of the fingers.

Drawing the skin is very much like the Merging Forms demonstration (page 40). For that exercise, you put two of the basic forms (e.g., a box and a sphere) in what looks like a sack. You can see the underlying forms holding up this outer sheath, but you're only drawing how it appears on the surface. This is the same concept as drawing the skin. All the anatomical forms lie just below the surface and are what give the body its shape. The more understanding you have of the three-dimensional qualities of the underlying anatomy, the more you will be able to sculpt the outer appearance of the body.

How much of the underlying anatomy shows on the surface is determined by how prominent the underlying anatomy is and how thick the skin is. An athlete who has worked to develop his or her physique and has a low percentage of body fat will show the muscles more clearly than someone who has thicker skin and less developed muscles. However, even for the bodies that have a higher percentage of fat, the bones and muscles determine its overall shape. They are just softened by the skin that mutes the underlying forms.

USING ANATOMY

When drawing something as complex as the human body, starting with a simplified form is a great way to quickly and accurately create the illusion of space. As you develop the drawing, you can add the shapes that better represent the anatomy. You still need to think of these as three-dimensional shapes rather than just lines and contours. You're not copying the model; you're re-creating him on the page.

As you develop your drawing, you will be covering up the anatomy with skin. Knowing the anatomy will help you flow one body part into another. It will help you visualize how the body changes as it moves. You'll be able to see the model more clearly because you know what to look for, and you will be able to re-create a model in a different position.

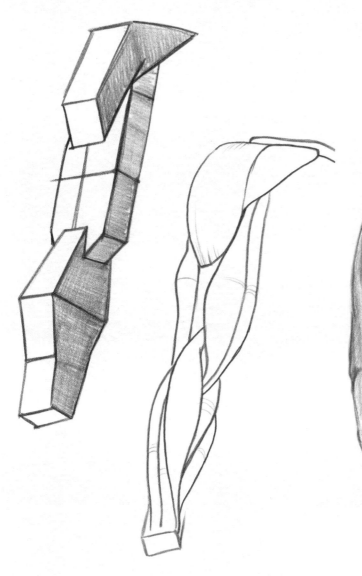

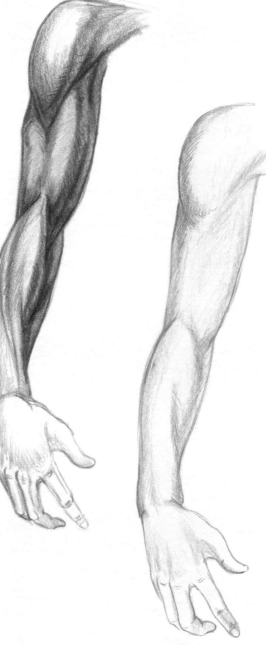

USE PHOTOS TO DRAW MUSCLES

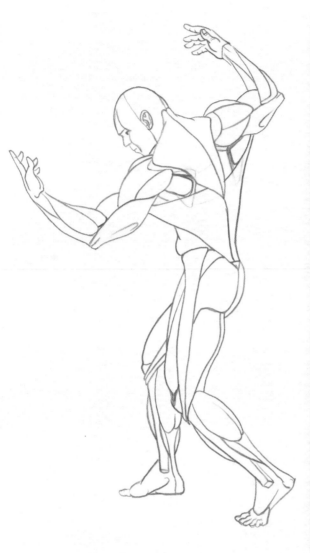

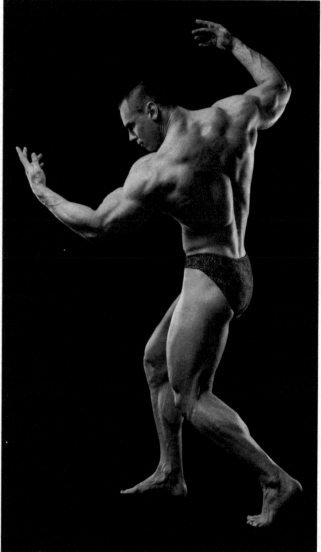

ISTOCK.COM/CIMMERIAN

1| Gather Photo Reference

Find a photo of a muscular model and place tracing
paper over the image.

2| Draw Muscles Over Photo

Draw the muscular forms on the tracing paper.
Remember, you're not just drawing lines of where the
muscles are but you are thinking about the three-
dimensional forms of the muscles as you draw them.

LEVEL UP CHECKLIST

Before you move on to the next chapter you should master
the basic skills highlighted in this chapter.

☐ Draw a head shape from any angle from memory.

☐ Have a working knowledge of how to draw features on the head.

☐ Know the three-dimensional shapes of the largest muscles in the
body, where they connect to the body and what they do to move
the body around.

☐ Have the ability to put skin on the figure and still be able to show
the underlying muscles affecting the surface forms.

PUTTING IT TOGETHER

Anything is easier when you have a step-by-step procedure to follow, and drawing is no different. On the next few pages, I review the steps discussed throughout this book and how you can use each step to build your final drawing. Starting with the Holistic Drawing demonstration (page 116), you'll see how to build a figure more holistically rather than completing one step before moving on to the next. It's important to be able to build a figure both ways. The more intuitive approach is possible once you master the basics, but the step-by-step approach is extremely useful when dealing with difficult poses or unfamiliar angles that require clearly working out the three-dimensional forms.

STEP-BY-STEP DRAWING

This first step-by-step sequence puts all the lessons you learned in this book into a structured procedure. Understanding how each of those steps works together is helpful when you need to analyze and break down a complex form or pose.

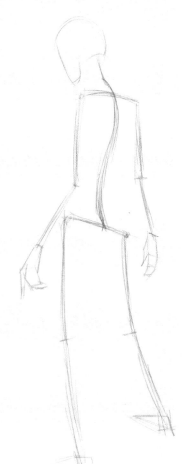

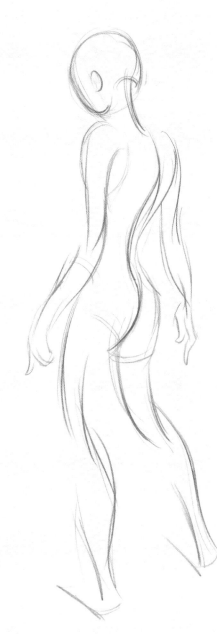

1 Start With an Armature

In Level 1 of this book you used an armature to clearly define a pose. An armature is great for clearly showing how the different parts of the body sit in space in relation to each other. It's also a great tool for working out the proportions of the figure.

While an armature is useful in inventing a pose and figuring out the positions of the limbs and trunk, a gesture drawing is a far better foundation for your drawing. So draw the armature off to the side and use it as a reference.

2 Make a Gesture Drawing

A gesture captures everything that an armature does—establishing the pose and proportion of the body, for example—but it moves and flows in a more organic way. It can also capture some of the muscle shapes and connections between parts more easily than an armature. So start your drawing by capturing the gesture.

The drawing on this page is dark so you can more easily see it. At this stage, the lines should be fairly light so you can change and refine as you go. As you build the drawing, the gesture drawing will nearly disappear, but its effect will carry through to the final rendering.

3 Create Volume

Once you have a gesture drawing that captures the pose, proportion, rhythm and attitude of your model, you can then begin to develop its three-dimensional qualities.

In Level 3, you created volume by sculpting spheres, boxes and cylinders into shapes that reflect the subject. This is how to clearly define how the body sits in space.

These shapes taper, bulge, merge and connect in ways that reflect the shapes of the body, but they aren't meant to be anatomically accurate. Their purpose is to define the figure in space and to build a solid structure where the muscles can be more clearly designed.

Creating volume in this way also gives you a three-dimensional map for working out how light falls on the figure. It's much easier to experiment with lighting effects on simple cylinders and boxes than it is on a figure where all the muscles are defined.

4 Add Anatomy

Adding the details of anatomy to a figure requires that you know the three-dimensional shapes of the muscles and where they connect to the bones. You'll use the same skills you honed when you learned how to draw a figure using simple volumes. But this time there are a lot more specifically shaped forms for each muscle.

A great way to keep your mind focused on the muscles is to name them as you are drawing them. This makes you think about each individual muscle and helps you keep things from getting jumbled together.

Keep in mind that you're very rarely drawing people who are both extremely muscular and very lean. This means that the muscles will be more subtle. They will, however, still influence the surface undulations of the body. Knowing what causes one area to rise and another to fall requires that you understand how the body is built anatomically.

Some major muscles are far more visible than others. The shape of the calves, the shoulders and the chest muscles, for example, are visible on everyone, so having a solid grasp of these shapes will take you a long way toward creating a believable figure.

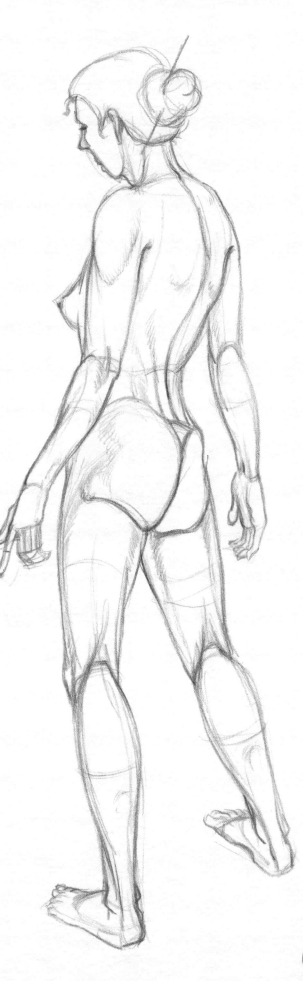

5 Draw a Total Figure

However you choose to finish your figure, whether it's a drawing, a painting, pen and ink, pastels or another media, you have to keep in mind that the person you are drawing is a whole thing and not a collection of parts. You don't want to overemphasize the anatomy and lose sight of the figure as a whole. You want the drawing to express a unified thought so that the viewer doesn't notice the parts of your drawing but gets a feeling about the character.

Ideally, your final rendering conveys something about your subject—a mood, an attitude, a personality—and none of the parts should draw attention away from the subject as a whole.

Your end goal is to connect with your audience by evoking a feeling in them. You want your drawing to feel real enough that they stop looking at your lines and tones and see the person that you've depicted.

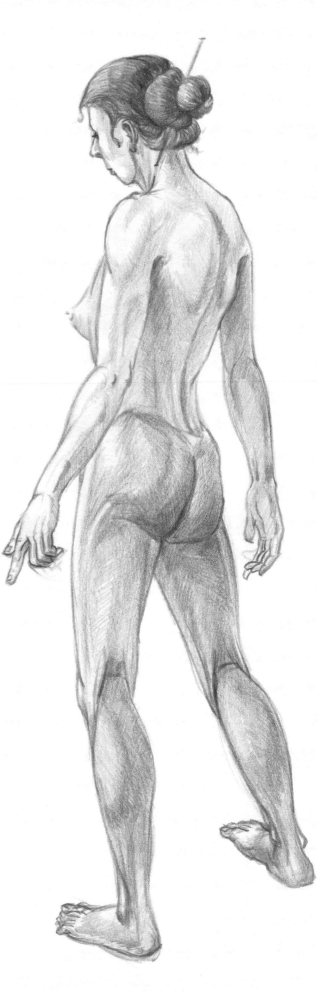

DRAW DIFFERENT BODY TYPES

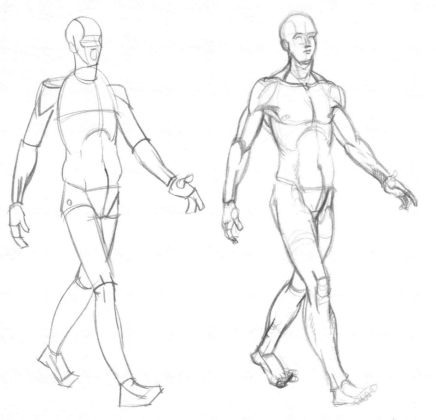

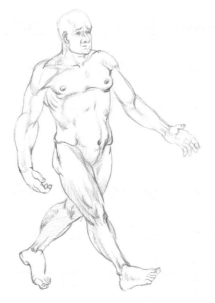

1| Draw a Figure

Start with a gesture drawing for a pose and build up the three-dimensional shapes for a figure. You can develop your figure however you like. It can be muscular, skinny, short or overweight.

2| Change the Proportions

Create a new gesture for drawing the same pose, but this time, build your figure with a different body type. You'll use different shapes and proportions to develop this new figure than you did for the first one. This exercise will help you practice building shapes and forms that fit your model rather than just repeating the same shapes on every figure you draw.

Extra Credit

Create a new drawing with unrealistic proportions. See how far you can distort the body. For example, you can create a character with tiny hips, a huge chest, very short legs, long arms and a tiny head. This will help you really stretch your skills in morphing anatomical shapes to fit what you imagine instead of what you've ever seen before.

HOLISTIC DRAWING

Once you've fully understood how to build a figure in steps, you'll find that you will start using the skills you've developed as you need them. The divisions between each step will blur. This only happens once you've internalized the basics of drawing. Instead of thinking about what the next step is, you'll be thinking about what you're trying to communicate with your drawing.

1 Make a Gesture Drawing

Once you're comfortable with the fundamentals of figure drawing, you'll start to naturally approach drawing more holistically rather than in parts. You won't follow a rigid procedure but will use the tools you need at the moment you need them.

When you start your drawing with a gesture, you can also start to capture some volume along with it. In the drawing on this page you can see the gesture lines that flow down the figure and also lines that wrap around the form (the thighs, arms and chest).

With better knowledge of the process, you will have the confidence to leave things out of your drawing as well. Knowledge allows you to simplify because you don't have to spell everything out. Being able to express something simply, clearly and confidently often makes for a compelling and beautiful sketch, but it requires a higher level of skill.

2 Build Up the Forms

As you build up your three-dimensional forms, you can still use gesture drawing techniques. You can capture volumes and anatomical parts as you keep adding more gesture-like lines.

The advantage of building your figure this way is that it keeps the flow of your gesture drawing, which makes your drawing feel more like it has movement.

The drawing should still be quite light, but if you find an edge of a form or the hard line of a bone that you want to define as a landmark, you can give it more emphasis.

At this stage, the drawing is beyond a gesture, but it clearly isn't the volumetric figure built in the Step-by-Step Drawing demonstration (pages 111–114). It's somewhere in between. There's still room for flexibility as the drawing develops and the figure becomes more of a whole rather than a collection of parts.

3 Add Anatomy

As the drawing develops, start to more clearly define all the parts of the figure. Drawing lightly in the previous stages allows you to explore with your pencil but doesn't interfere as you darken your lines for anatomical forms.

Again, you're not developing in steps as before. Use all of your tools in tandem—gesture, basic forms, anatomy, values—to build the drawing.

You might spend more time clarifying the anatomy in one area because you want to draw attention to that part. On the other hand, you'll use simpler gesture lines to deemphasize those parts you don't want to draw attention to.

4 Finalize Your Drawing

Your final drawing will develop organically. Put down a line and the next will be in relation to the previous. With this method, you are constantly drawing and actively responding to the effect you created. You may have a direction in which you want to head, but the final image will be a result of many small decisions you make along the way.

This is the fun part of drawing. Forget about fixed processes. You don't need to think about lines and forms once those skills are ingrained. Instead, take your toolbox of skills along for a journey. Where you end up is a combination of your abilities, your personal taste and the decisions you make as you work.

DRAW IN DIFFERENT STYLES

Every artist treats the figure differently. Michelangelo created idealized, heroic figures. El Greco painted elongated figures that were graceful and elegant. Some artists, such as the Art Deco painter Tamara de Lempicka or the Art Nouveau illustrator Alphonse Mucha, created highly stylistic images designed in the fashion of their times. Käthe Kollwitz drew her expressive charcoal drawings to impact the viewer on a visceral level. Egon Schiele used line and often distorted figures to explore the rawness of the human experience. Humorous artists, such as Honoré Daumier or Heinrich Kley, use exaggerated and cartoonish figures to toy with our expectations. Pablo Picasso's fractured figures gave us a new way of seeing people all together. Every artist depicts the figure in his or her own unique way, and you, too, need to find a style that reflects your sensitivities and ideas on art.

Knowing the skills presented in this book will give you a foundation for discovering how you want to express the human form in your own work. If you want to draw and paint realistically, then you can delve deeper into the study of anatomy. If you want to draw stylistically, then you can focus on designing your figures with shapes and proportions that express your personal style.

If you don't have an idea of where you want to go with your art, you can explore the figure through a variety of approaches. This assignment gives you one way to explore different styles.

1| Gather Reference Images

Gather several drawing or paintings of figures from an artist that you like stylistically. It doesn't have to be a fine artist. You can choose an animator you like (such as Glen Keane or Hayao Miyazaki) or a comic book artist (such as Todd McFarlane or Frank Miller), or anyone who really inspires you.

2| Analyze the Work and Sketch

Analyze what makes each drawing look the way it does. How are the shapes and lines put together? Are the proportions tweaked or exaggerated? Is there a strong sense of volume, or is it more flat or graphic? Take some time and copy the artist's drawings to really understand how he or she created the figures.

3| Choose a Second Artist

Find a second artist whose subject matter you like. What makes this art appealing to you? What does it say to you personally?

4| Combine the Two

Now draw a figure as if you were the first artist you chose trying to express the ideas of the second artist. For example, how would Degas express the ideas of gender and identity that Frida Kahlo explored? How would Chuck Jones depict the experiences of ordinary rural Americans that Thomas Hart Benton painted? Have fun mashing up different artists and styles.

The main thrust of this exercise is to get you to use your skills in different ways stylistically and to think about ideas that are important to you. It will help you see how other artists approached the figure and how they used the human form to express an idea.

LEVEL UP CHECKLIST

Before you move on you should master the basic skills highlighted in this chapter.

☐ Have a set procedure when you build a figure. Start from a gesture, build up the three-dimensional forms, add anatomy and add detail. Having a set system helps you know what to do next. You don't always have to be rigid in your process, but having an order that you generally follow brings confidence and consistency to your work.

☐ Adapt any anatomical shape to fit the body you're trying to draw, regardless of whether it is a model in front of you or a character you imagine.

☐ Begin to develop your own style and approach to drawing. Exposing yourself to artistic styles that appeal to you—and those that don't—inform the choices you make in your art. The more you know, the more you can put into your own work.

WHERE TO GO FROM HERE

Keep drawing. Whether you practice drawing from a live model, rely on photos or invent figures from your imagination, you can always find ways to build your skills. A sketchbook that you draw in as you go about your day is also a great way to stretch your abilities and a good place to jot down ideas you come across.

If you enjoy drawing realistic figures, then focusing on anatomy will allow you to add more and more detail to your drawings. If you prefer a more stylistic approach, then keep exploring and experimenting and see where it takes you. Regardless of your goals, the fundamentals of drawing will always play an important part in your craft.

Most important, have fun drawing. Drawing is a great skill to have, and it's also a pleasurable way to record your experiences and express yourself.

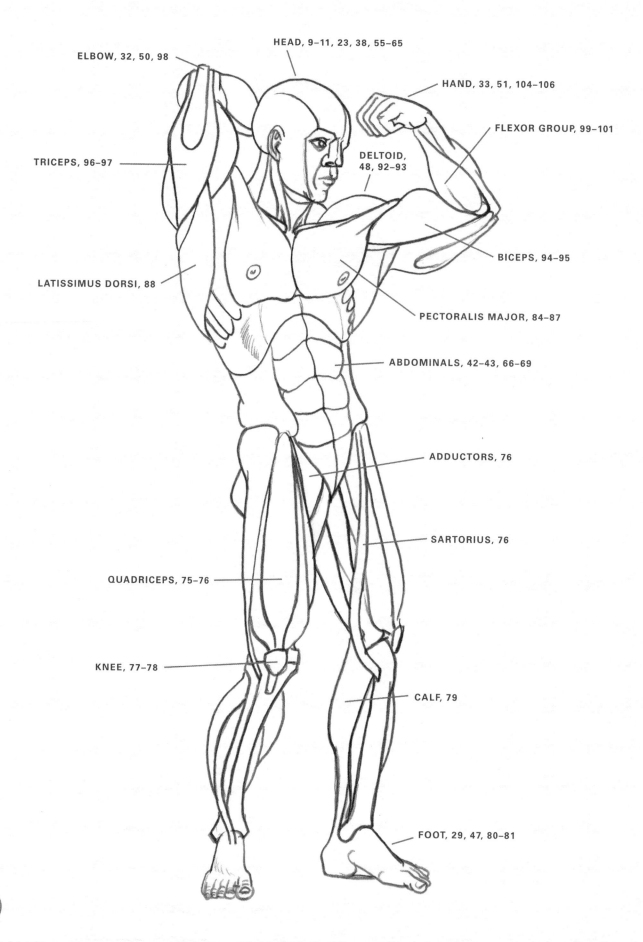

ELBOW, 32, 50, 98

HEAD, 9–11, 23, 38, 55–65

HAND, 33, 51, 104–106

FLEXOR GROUP, 99–101

TRICEPS, 96–97

DELTOID, 48, 92–93

BICEPS, 94–95

LATISSIMUS DORSI, 88

PECTORALIS MAJOR, 84–87

ABDOMINALS, 42–43, 66–69

ADDUCTORS, 76

SARTORIUS, 76

QUADRICEPS, 75–76

KNEE, 77–78

CALF, 79

FOOT, 29, 47, 80–81

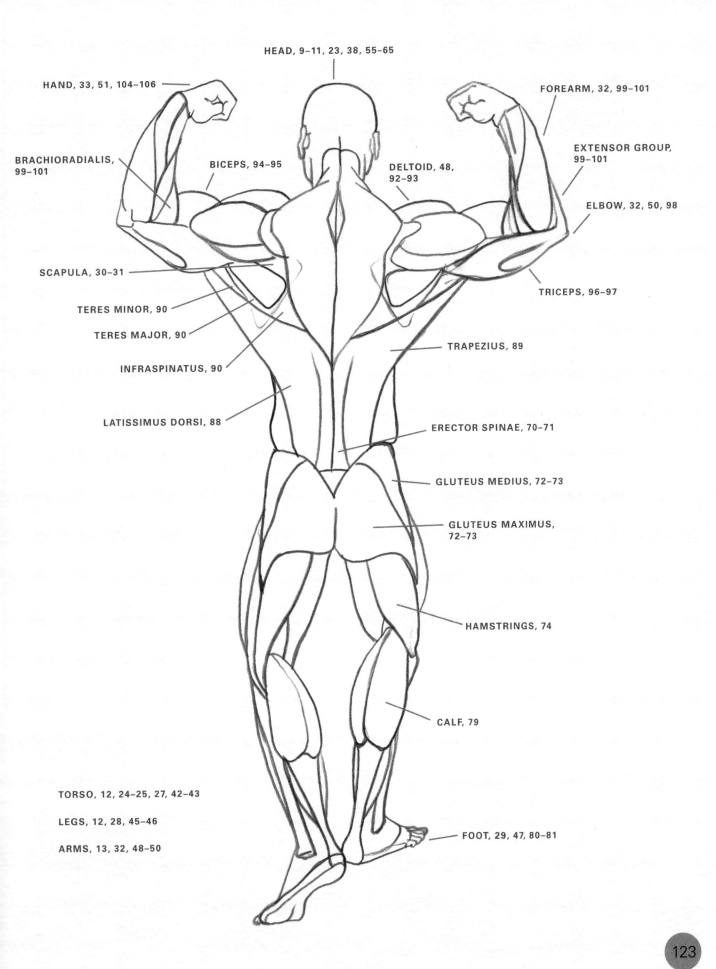

HEAD, 9–11, 23, 38, 55–65

HAND, 33, 51, 104–106

FOREARM, 32, 99–101

BRACHIORADIALIS, 99–101

BICEPS, 94–95

DELTOID, 48, 92–93

EXTENSOR GROUP, 99–101

ELBOW, 32, 50, 98

SCAPULA, 30–31

TRICEPS, 96–97

TERES MINOR, 90

TERES MAJOR, 90

INFRASPINATUS, 90

TRAPEZIUS, 89

LATISSIMUS DORSI, 88

ERECTOR SPINAE, 70–71

GLUTEUS MEDIUS, 72–73

GLUTEUS MAXIMUS, 72–73

HAMSTRINGS, 74

CALF, 79

TORSO, 12, 24–25, 27, 42–43

LEGS, 12, 28, 45–46

ARMS, 13, 32, 48–50

FOOT, 29, 47, 80–81

INDEX

North Light Books
An imprint of Penguin Random House LLC
penguinrandomhouse.com

Printed in the United States of America
10 9 8 7 6 5

ISBN 978-1-4403-5316-1

Edited by Noel Rivera and Christine Doyle
Designed by Jamie DeAnne

About the Author

Jeff Mellem is a professional artist and graphic designer.
He earned a Bachelor of Fine Arts from the California State
University, Fullerton, and studied at the American Animation
Institute in North Hollywood, California. His previous book,
Sketching People: Life Drawing Basics, was released by North
Light Books in 2009, and he was one of the artists featured in
*Sketchbook Confidential: Secrets From the Private Sketches of
Over 40 Master Artists.*

For more on his work, visit www.jeffmellem.com.

Acknowledgments

I would like to thank my family—Glenn, April, Danny and Eric—for all their support and encouragement. Thank you for always showing interest and excitement for my various projects.

I would also like to thank the staff at North Light Books for supporting this book, particularly Mona Clough and Noel Rivera for ushering the book to publication. A special thank-you to Christine Doyle for her talents in helping me edit and refine the text. I also appreciate Kim Catanzarite's help in copyediting the text and Jamie DeAnne's work in designing the book.

Further Reading

This book was designed to give you the tools to approach drawing people and inventing figures. It isn't an exhaustive reference for all the muscles and bones in the body. Anatomy books designed for artists are great for figuring out what muscle you're seeing on a model, and they can also help you figure out the shape of a muscle and how the muscles fit together. Below are some books that I've found helpful when learning to draw more realistic figures.

Human Anatomy for Artists: The Elements of Form by Eliot Goldfinger, Oxford University Press, 1991

Strength Training Anatomy, 3rd Edition, by Frederic Delavier, Human Kinetics, 2010. See other books in this series as well.

Dynamic Anatomy: Revised and Expanded Edition by Burne Hogarth, Watson-Guptill, 2003

Bridgman's Complete Guide to Drawing from Life by George Bridgman, Sterling Publishing, 2009

Also, a company called 3D4Medical makes excellent programs for the computer and tablets that show the muscles in three dimensions. It's really useful for seeing the shapes of the muscles, what they attach to and how they weave together.